Fashion Cats

By TAKAKO 著 a.k.a. Prin Mama

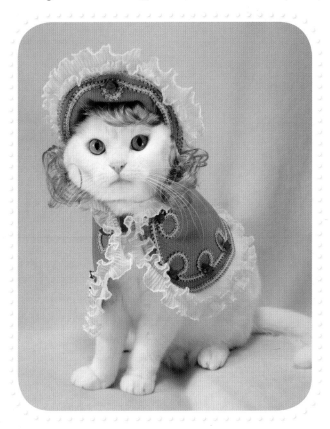

VICE

Fashion Cats
CONTENTS 目次

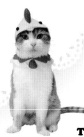
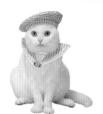

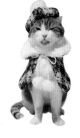
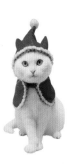

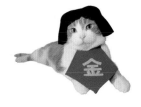

Photo on the previous page:
Queen Stephanie's Bonnet and Dress

Prin transforms into a queen with a bonnet
adorned with splendid curls. She'll be the belle of
the ball with this outfit. Let's go to Versailles and
dance the night away with a noble gentleman.

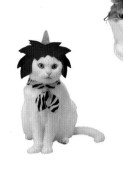

Prin's face (actual size)
プリンちゃんのお顔・実寸

Introduction

Prin is a cat supermodel. She wears clothes, strikes a pose, and lets you take photos of her. She's also a very mysterious cat...so strange that sometimes even I, Prin's owner (a.k.a Prin Mama), wonder if she's from outer space! Perhaps the release of this book is in debt to Prin's super powers.

I often notice strange incidents occurring when I'm with Prin. This may not seem like a big deal, but my wishes seem to come true with such surprising frequency when she's around. Perhaps this is all in my head, but who knows?

For example, only a few years ago I was thinking about how amazing it would be if I could introduce Prin to people all over the world. Not long after, we were featured in *Vice* magazine and the article was seen in 15 countries worldwide. After that, publications from all over the world came to interview Prin one after the other.

My intention is not to force cats to wear clothes. That's why I'm amazed to find that all these people from all over the world are coming to see what we're doing. Why are they so interested? I wonder what will happen to us next? Prin, Kotaro, and I ask ourselves that every day, full of expectations for what the future might bring. We live each day with joy and appreciation.

I will be eternally happy if those who pick up this book are amazed by the fact that Prin and Kotaro are real live cats who wear clothes, or else find the outfits so amusing that they laugh out loud, or even decide to live with a cat after flipping through these pages. I would like to extend my warm appreciation to all those who supported Cat Prin and the release of this book. I hope that all of you are blessed with pleasantly mysterious surprises too.

"Cat Prin - Tailor of a Cat" store owner & designer
TAKAKO a.k.a. Prin Mama
At Prin's atelier, May 22, 2009

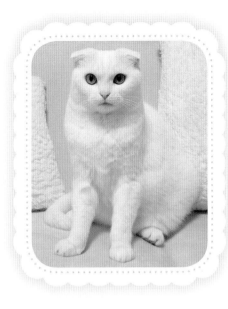

NAME • Princess Prin

FROM • Planet Prin

BIRTHDAY • March 13, 1999

BREED • White Scottish Fold

LIKES • Dried chicken fillet snacks

JOB • Fashion model (forte: luxurious outfits)

HOBBY • Investigative research into the water found in the toilet bowl at Prin's house; protecting Prin Mama

SPECIAL SKILLS • Brushing her teeth and hair by herself

PERSONALITY • Calm and gentle. Her daily routine includes observing Prin Mama's physical and mental health. She is strictly professional when it comes to modeling. During the shoot she gets hungry, so Prin Mama feeds her dried snacks directly into her mouth. Despite this, she never forgets to ask for compensation for her hard work (i.e. more snacks) after the shoot is over.

NAME • Prince Kotaro

FROM • Planet Prin

BIRTHDAY • April 24, 2002

BREED • Red & white Scottish Fold

LIKES • Meals and Prin Mama

JOB • Fashion model (forte: funny costumes)

HOBBY • Sneaking up on Prin as she leaves the toilet; snuggling up to Prin Mama

SPECIAL SKILLS • Sitting on Prin Mama's lap, putting one paw up and touching her face with it as she says, "Who wants dinner?" (That's a big "Me!")

PERSONALITY • A big baby who loves getting affection. He gets sad and cranky if Prin Mama doesn't cuddle him at least once a day. He's cute, but he dribbles all over you when you cuddle him (sometimes we call him "Prince Dribble"). He loves his big sister Prin, and keeps trying to lick her despite the fact that she scolds him every time. He doesn't care though, because he's a happy, carefree cat.

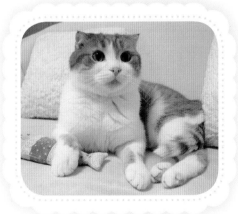

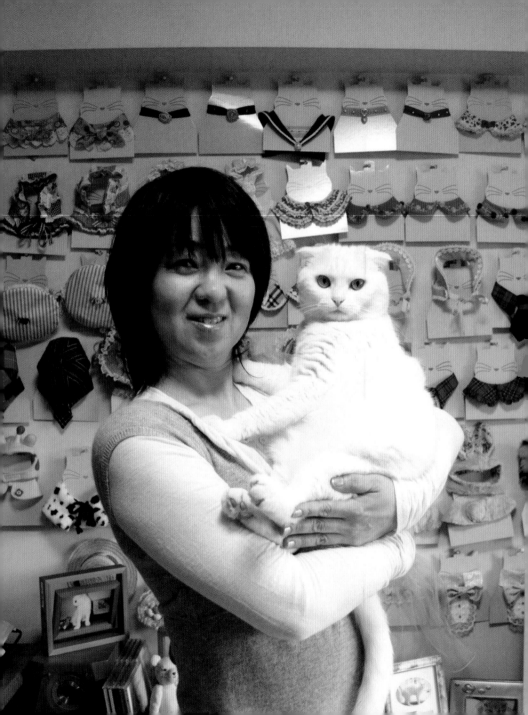

Interview by Tomokaflex

From *Vice* magazine, April 2008

The Story Behind the Cat Clothes ♪

Tell us how you first began the world's best clothing store for cats.

Takako Iwasa: In August 2000, a booming voice suddenly rang out over my head that said, "Do something this year!" I panicked and didn't know what to do. I could hear the voice while I walked down the street. "Do something this year!" I kept looking around to see who was telling me to do this but no one around me seemed to notice it, and that's when it finally clicked that I was the only one who could hear it. But it was so loud, and right above my head! I don't know how to explain it, but I realized that this must be a

revelation from God! I accepted it as that. So although I was a little freaked out, I began the online store called Cat Prin on December 10 of the same year. I was relieved that I made the deadline that God gave me.

I'll bet! Were there any particular events that led up to you hearing the voice from God commanding you to make cat clothes?

No, it was so sudden. I was actually suffering from a serious illness for about eight years around that time, and I was getting anxious about whether there was any work that I could do at home since working outside was no longer possible. Then one day I saw a story on TV about a 16-year-old girl from rural Japan who started her own business. Apparently she started out by selling t-shirts online that she bought wholesale, and when those sold out, she borrowed some money from her dad and opened her own little shop in the village. She would ride the night bus to Tokyo over the weekend to stock up on clothes, and people would snatch them up as soon as she sold them in the store. She's only 16, but she's now the boss of her own company. When I saw her, something inside of me crumbled away, and I realized what a wonderful country Japan is. I mean, it's a country where if someone is selling something, and someone else wants to buy it, then it's accepted as a legitimate business. I was surfing the net with my computer, which was the only thing I purchased with my retirement money, and I realized that this was what I had to do. Also, my mother is a great seamstress and had made a little cape for my cat Prin, who was lying right in front of me. A computer, clothes for cats, and Japan, a country where anyone can do business! Cat Prin is all these things combined. And it coincided exactly with when I heard that voice telling me to "do something."

That is one inspirational story. Did you think there would be a big market for cat fashion?

Well, I'm sure that people have been making clothes for cats privately, but I

didn't come across anybody who was publicly announcing that they were "cat tailors" back then. It wasn't exactly a taboo, but I think that generally you were frowned upon, like, "Clothes for cats? Ridiculous!" But after I started the shop I realized that there was actually a big demand for these things, and customers would come up to me and say, "I had been wanting to dress my kitty up for so long, I used to dress them up in dog clothes before you came along," like they were waiting for something like this forever. Even before I began the business, for some reason I got it into my head that there must be at least five people in Japan who would love my clothes. I don't know why. Anyway, I decided to do my best, even if it was just for those five people. And if other people didn't like it, I would quit, because it would mean that I was out of sync with the rhythms of the universe.

But as it turns out, you and the universe were very much as one.
Yes, to my surprise I didn't hear any complaints, just happy customers saying, "I was waiting for a shop like this!" Maybe it's because similar shops already existed for dogs. Apparently dog-clothing stores had a hard time at first. But now that society has been through that, I feel that we're living in a time of choices, whether it's "I don't want my cat to wear anything" or "I want to dress up my cat." Initially, I had only planned on making simple items like necklaces and shirt collars rather than entire outfits, but it gradually evolved from there. I always consider my products fashionable. They're not dress-up costumes to transform your cat into something else. It's more about aesthetics.

So once you had the idea, was it tough getting it off the ground?
Yes, I made a lot of mistakes at the beginning. You can't ask for advice because nobody has done it before. At first, some pet stores offered to sell a few of my products, but even then they said, "You should make dog costumes instead, that's where the money is." After that, I decided not to

listen to anybody else's opinion except fortune-tellers and people with mystical powers, and they all told me the same two things, which reassured me immensely. What do you think they said? The first thing was "You will succeed" and the second thing was "You will have to live with your sickness for the rest of your life." They all said that these were absolute truths.

That's a whole lot of truth. Do you make all of the clothing by hand?
Generally yes, although sometimes I ask ladies in the neighborhood to help out. If I need to bulk produce a certain product then I ask a factory, but even then it's still two ladies sewing everything by hand. Dogs are fairly big so you can sew everything with a machine in one go, but only a tiny amount of cloth is used for cat's clothes so they always have to be hand sewn. I didn't even know how to sew at first, so I didn't know that you don't have to make every single stitch look perfect, especially if it's a part that isn't visible. I was often told to take it easy with the stitching. I'm not so concerned with whether they sell, seeing as the whole thing started because I wanted to make my cat Prin look cute.

Prin is the white Scottish Fold who models some of the costumes, right?
Yes. Back then I wanted to own a completely white Scottish Fold, which was pretty rare at the time. Then one day I was flipping through a magazine and I saw the words "White angels are born." Before I knew it, I was calling them up, and I went to the breeder's house to see the kittens. Health-wise I was in a terrible state and I can't believe I actually went, but I did and found out that there were seven kittens altogether. They were all tangled up and playing with each other. I stared at them for about two hours but I still couldn't see any of their faces properly, plus I was sick, and I didn't know what to do. But at the very end, this one kitten with a bright red nose came up to me, so I decided to get that one and eventually named her Prin. Looking back, I think that she actually chose me, like we were meant to be. She turns nine in March. She's a

very strange cat. When I was sick, she never woke me up to ask for breakfast, and when I did wake up, I would find a toy mouse next to my pillow. She showed a lot of concern for me and would only play in my eyesight when I was lying in bed. Even now, she never wakes me, no matter how hungry she is.

She's so cute and seems so mellow. My cat would never let me put all those hats and cloaks on her.

Yes, I only recommend my designs for cats who are okay with wearing collars at the very least. If they can't even wear those, then there's no way they can wear my clothes. Same with slightly untamed cats. When you see Prin wearing them you think, "Oh, maybe my cat can wear these too," but actually it's not that simple. For example, if it's a helmet-shaped headpiece, most cats don't like their ears folded over. That's why I separate my products into three types: advanced level, mid-level, and beginners. The beginner products are mostly items that you place around the neck. I use Velcro for most of the clothes so that they're easy to fasten. I recommend these for cats who can wear collars. Mid-level products are clothes that have long bits hanging from the neck. Cats seem to really hate this. A lot of cats can't wear the sailor-style school uniform because of the hanging gold bit in the front. Hats and capes are the advanced products. We also have a "natural" level for cats who can't wear anything, which basically means, "You don't have to wear anything, just browse through the site and enjoy the photos!"

Funny. Who are your customers?

A lot of them are regulars. There are a few very passionate customers who always buy my new costumes. I have about 1,500 customers right now.

Have you had any strange requests?

Yes, mostly from men. Usually it's something like, "I want to dress my cat up as a bunny rabbit, and I also want rabbit ears myself. Can you make

matching ones for us?" to which I say, "Sorry, I don't make human costumes." Numerous men have asked me to make matching costumes with their cats, but no women yet. It's very interesting.

Do you have any pointers on how to convince a cat to wear clothes?
Always think about the cat's personality beforehand, and don't force the costumes upon them. Try to do it when they're in a good mood, and say encouraging words to them. Cats love to be complimented. You can't be half-assed about it either. You've got to be like, "OH MY GOD, you are so CUTE, you're the best cat EVER!!" and they will actually feel it and feel better about wearing the clothes. Compliment your cat, and they will definitely get better at wearing clothes.

Which is your favorite cat outfit?
I love them all. They're like my children. But I guess I especially find the Versailles series interesting. I was awestruck when I found the material for the blond wig used in that series. I went to buy a tiara at a wholesaler that had a huge selection of pins and other things to put in your hair, and that's when I found these wigs. The hats look so much better with the hair! Prin looks fantastic with blond hair, by the way. I'm surprised how far I've come with the intricacy of the costumes myself.

You've even made an official Hello Kitty costume for cats.
Yes, the first Hello Kitty headpiece ever. My costumes are usually only two-sided but this one is fully three-dimensional. It was interesting to see how you can three-dimensionalize flat objects, and it was around this time that I came to love the whole craftwork thing. It took six months and 22 prototypes until we got it right. I was near tears. Sanrio had to check every single nametag and they would pick out the ones that weren't good enough. The embroidered Hello Kitty mark also had to be checked one by one, and

they'd say, "The nose isn't right, the eyes aren't right," and so on. There were so many problems I was about to give up! But the Hello Kitty symbol embroidered on this costume is wearing a blouse, and this is a Cat Prin and Sanrio original mark that can't be found anywhere else, so it's quite valuable. In terms of the shape, it was really difficult trying to express the roundness of Hello Kitty on a cat's head, which is actually oval shaped.

What's your ultimate dream outfit?

I'm interested in old England at the moment, like the clothes that the British ladies and gentlemen wore 200 or 300 years ago. Vests, ties, and hats like what Peter Rabbit wears, long flowing skirts, that kind of thing. I've made about 150 costumes so far. I always thought that one day I wouldn't be able to design any new costumes anymore because I'm not really a designer type, but the inspiration just keeps coming. There's never a time when I don't have a new costume idea in my head. I think that the more I make them, the more inspiration will keep flowing. That, and encountering new material.

Tell us about your plans for the future.

To tell you the truth, I don't believe that I was born just for Cat Prin. I think that I am still in the process of reaching my true destiny. My ultimate dream is actually to become a fantasy writer. I'm a terrible writer, but I feel like I can write about things that are out of this world. It's a long time ago now, but about two years ago a title for a book popped into my head: Christina's Children. It's a three-part series, and I already have a pretty good idea of the whole story. It seems like I won't be working on it for another year or two, though, since I'm so busy with other things. But it will be interesting if I can make this happen, and maybe even have a Hollywood movie based on it. But if it doesn't happen, that's okay too. More realistically, it would be nice to have a Japanese TV series based on this book. I often talk with my friends about which actors I want playing which characters. I think that's when I feel happiest.

Princess ♥ Prin

My name is Princess Prin. I came
from a distant planet called
Planet Prin. The long, flowing
dress and the tiara on my head
give fine testimony to my status
as a princess. Now, why don't
you become a princess too?

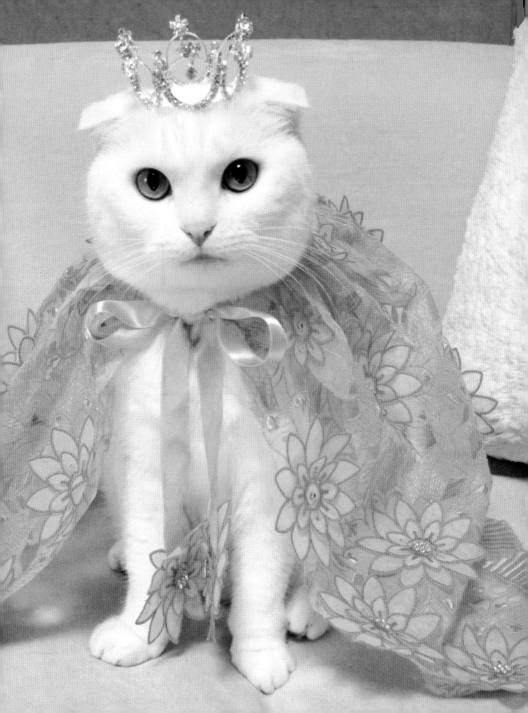

Wedding of a Prince and Princess

The prince and princess of Planet Prin are
having a wedding today. Let's go to church
with sparkling tiaras on our heads. Oh wait!
First, we have to practice how to kiss ♪ Smooch!

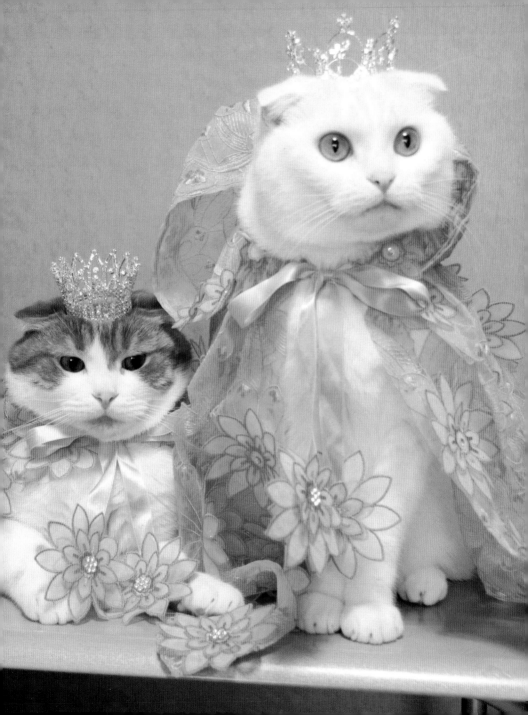

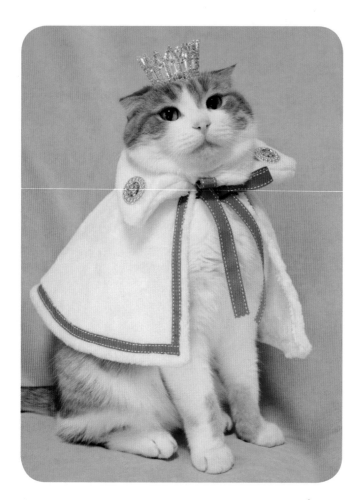

King's Coat

I am the king of Planet Prin. This dignified coat turns me into a king in a flash. Don't I look cool with my chest stuck out in confidence?

Queen's Coat

When I wear my long pink boa decorated with tiny roses, I try to stand as straight as I can. It's important to straighten my spine, show my two front paws like so, and place one paw slightly in front of the other. You mustn't forget to look straight ahead either.

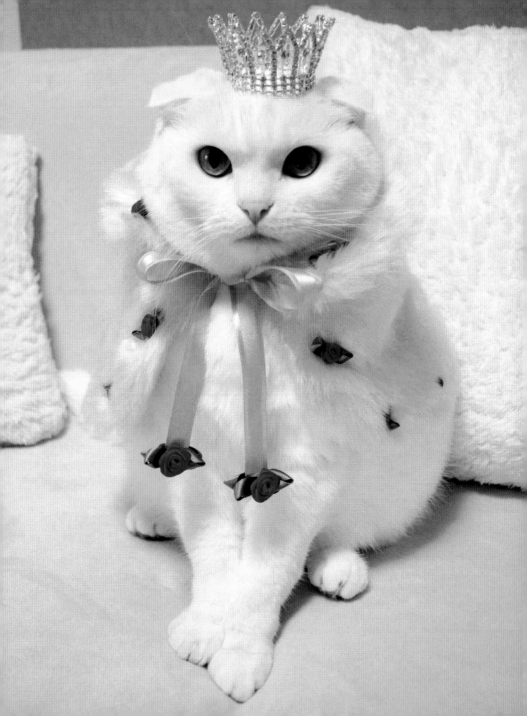

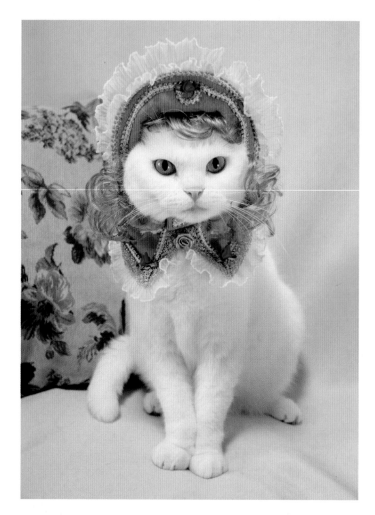

Princess Stephanie's Bonnet and Blouse for the Ball

Do you like my blond curls? I think it's especially stylish to have your bangs curled like mine. The pleated frilled lace on the bonnet and the shiny gold lace on the blouse brings out the cuteness in every single cat.

Princess Margaret's Bonnet and Dress

I'm wearing Stephanie's outfit in a different color. It's a dress adorned with double pleated lace and gold lacing. I wear this on special occasions! Today, it's for a ball that's to be held at the palace on Planet Prin. I'm going to strike up a conversation with a dashing prince.

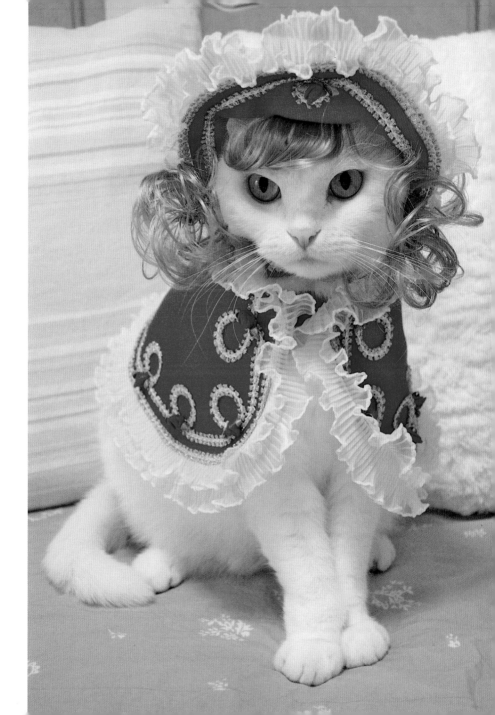

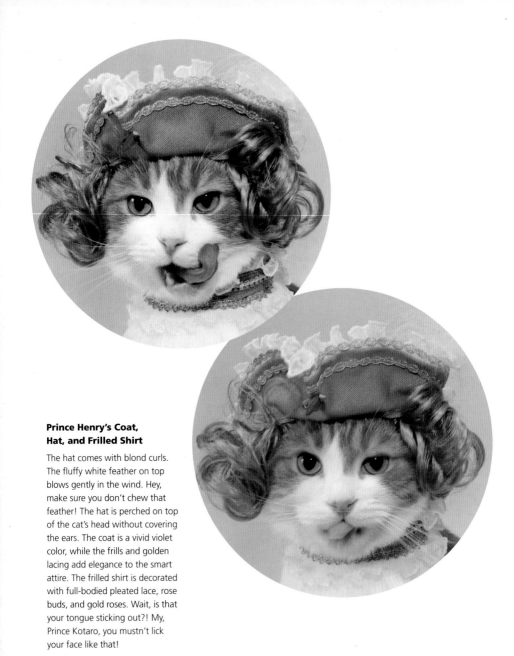

Prince Henry's Coat, Hat, and Frilled Shirt

The hat comes with blond curls. The fluffy white feather on top blows gently in the wind. Hey, make sure you don't chew that feather! The hat is perched on top of the cat's head without covering the ears. The coat is a vivid violet color, while the frills and golden lacing add elegance to the smart attire. The frilled shirt is decorated with full-bodied pleated lace, rose buds, and gold roses. Wait, is that your tongue sticking out?! My, Prince Kotaro, you mustn't lick your face like that!

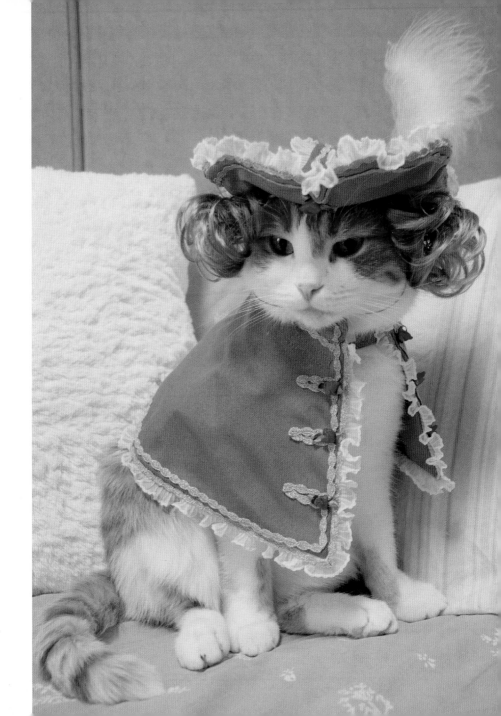

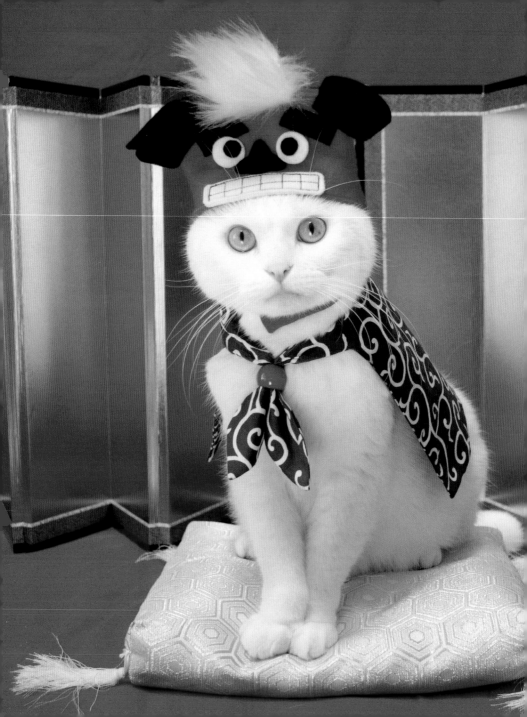

A Few More Sleeps Until That Special Day

Chinese Lion Dance Transformation Kit

Celebrate the new year by transforming your cat into a Chinese lion. Your Chinese lion cat will protect you from evil and help you welcome a fabulous new year.

"I, scary lion cat, will exorcise all of the bad vibes out of your life!"

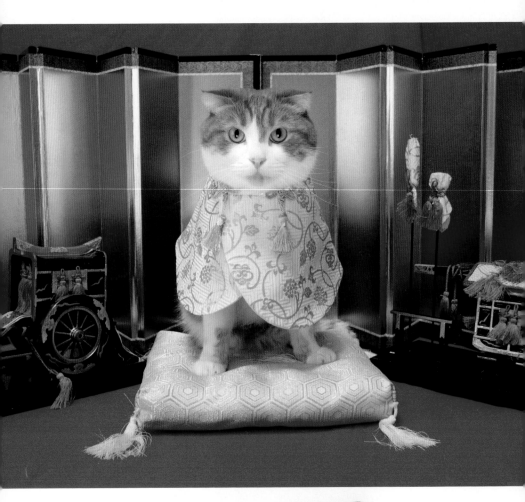

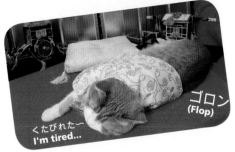

くたびれた〜
I'm tired...

ゴロン
(Flop)

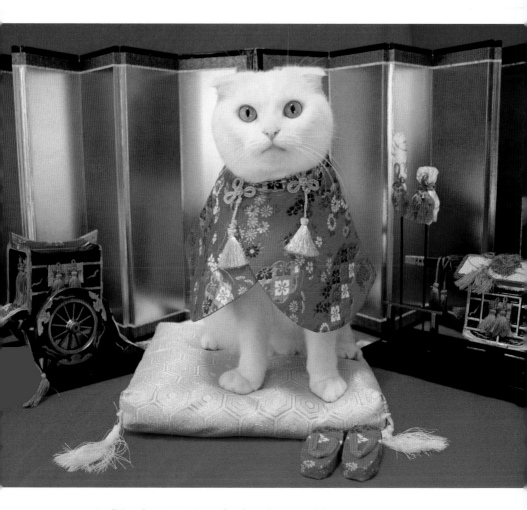

Traditional Japanese Coats for the Princess and the Master

Coats for the master and princess of the Japanese Country on Planet Prin. The young prince and princess will ride an ancient-style court carriage, whispering words of gratitude to their mothers and fathers as they ride off together. This is a traditional Japanese coat that will make every cat the center of attention. I made this outfit because one day, out of the blue, I realized that I might have spent my former life as a woman who lived in the Inner Chambers of Edo Castle during the Edo Period. I was soon overcome with the desire to make a glamorous kimono, and this is what I eventually created. This outfit is suitable for New Year's celebrations, the Seven-Five-Three children's festival, as well as the Boy's Day and Girl's Day Festivals. "Oh no! The young prince has lost his patience! Prince, please get up!"

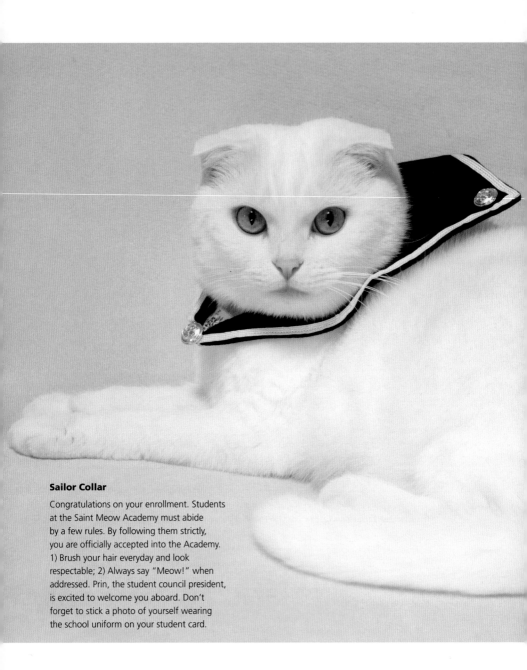

Sailor Collar

Congratulations on your enrollment. Students at the Saint Meow Academy must abide by a few rules. By following them strictly, you are officially accepted into the Academy. 1) Brush your hair everyday and look respectable; 2) Always say "Meow!" when addressed. Prin, the student council president, is excited to welcome you aboard. Don't forget to stick a photo of yourself wearing the school uniform on your student card.

入学証書

プリンセス・プリン さま

ご入学おめでとうございます♪
貴猫は聖にゃんこ学園の制服であるセーラーカラーを
上手に着こなし、日々おしゃれに精進し、
よく食べ、よく寝て、よく遊び元気に学園生活を
お送りください♪

校則 1. 毎日毛づくろいをして身だしなみを整えましょう。
　　　2. お返事ははっきり「ニャン！」といいましょう。

聖にゃんこ学園　理事長　プリンママ

ネコのお洋服屋さん　キャットプリン　発行

[translation]
Certificate of Enrollment:
Ms. Princess Prin

Congratulations on your enrollment.
We look forward to seeing you wear
the uniform at Saint Meow Academy,
the Sailor Collar, with style. Devote
yourself to fashion, and eat, sleep,
and play well during your time at the
Academy.

School rules:
1: Brush your hair and look
respectable
2: Always say "Meow!" when
addressed

Prin Mama, Chairman of Saint
Meow Academy
Issued by Cat Prin - Tailor of a Cat

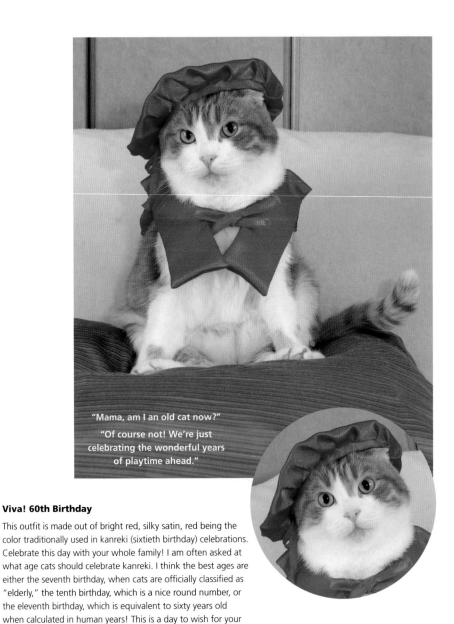

"Mama, am I an old cat now?"

"Of course not! We're just celebrating the wonderful years of playtime ahead."

Viva! 60th Birthday

This outfit is made out of bright red, silky satin, red being the color traditionally used in kanreki (sixtieth birthday) celebrations. Celebrate this day with your whole family! I am often asked at what age cats should celebrate kanreki. I think the best ages are either the seventh birthday, when cats are officially classified as "elderly," the tenth birthday, which is a nice round number, or the eleventh birthday, which is equivalent to sixty years old when calculated in human years! This is a day to wish for your cat's longevity. Kotaro has turned seven too. He's still a baby, and I hope he lives happily for a long time yet.

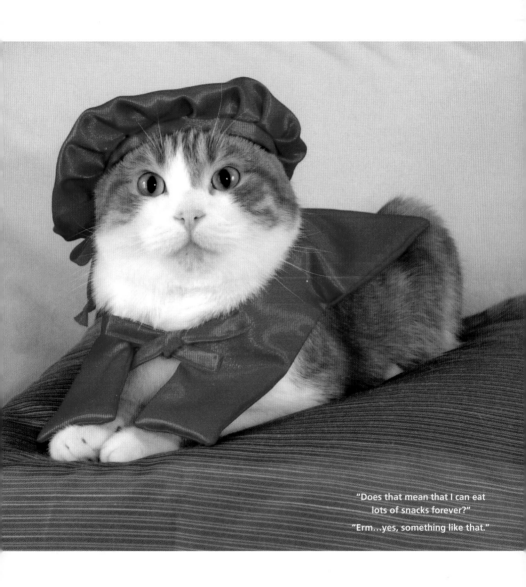

"Does that mean that I can eat
lots of snacks forever?"

"Erm...yes, something like that."

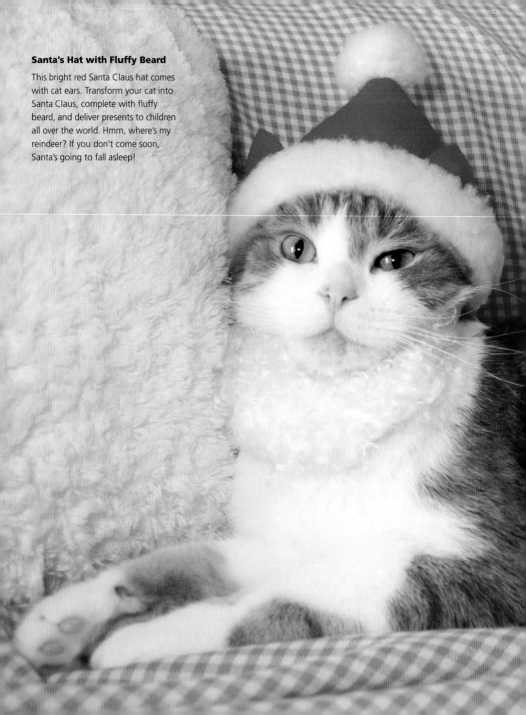

Santa's Hat with Fluffy Beard

This bright red Santa Claus hat comes with cat ears. Transform your cat into Santa Claus, complete with fluffy beard, and deliver presents to children all over the world. Hmm, where's my reindeer? If you don't come soon, Santa's going to fall asleep!

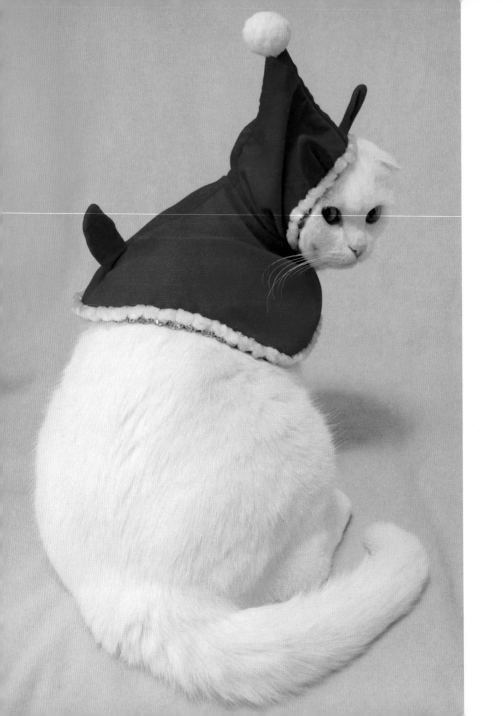

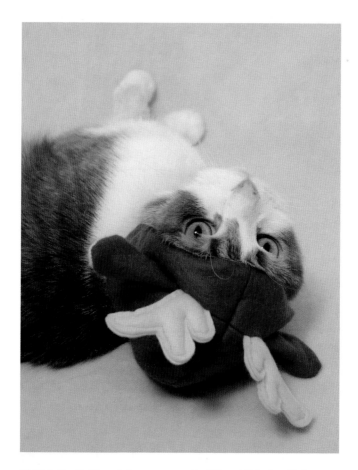

Glittery Santa Claus Cat

Mamas and papas will love this Santa Claus outfit, complete with cute ears and tail.

"What shall I get mama and papa this Christmas? What gift should I leave next to their pillow?"

Red-Nosed Reindeer Hat

Transform your cat into a handsome reindeer with this hat, which comes with a red pompom and Christmas bell that sit under the chin.

"Don't fall asleep yet, Mr. Reindeer."

"Okay…I'll try…"

"Hey! wake up!"

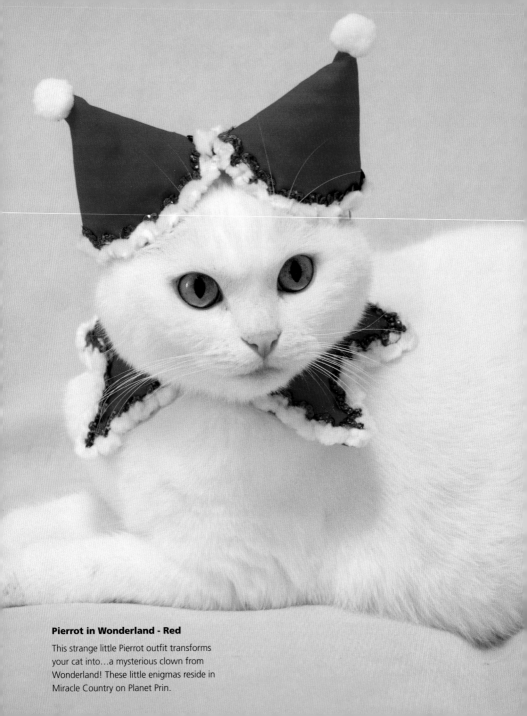

Pierrot in Wonderland - Red

This strange little Pierrot outfit transforms
your cat into…a mysterious clown from
Wonderland! These little enigmas reside in
Miracle Country on Planet Prin.

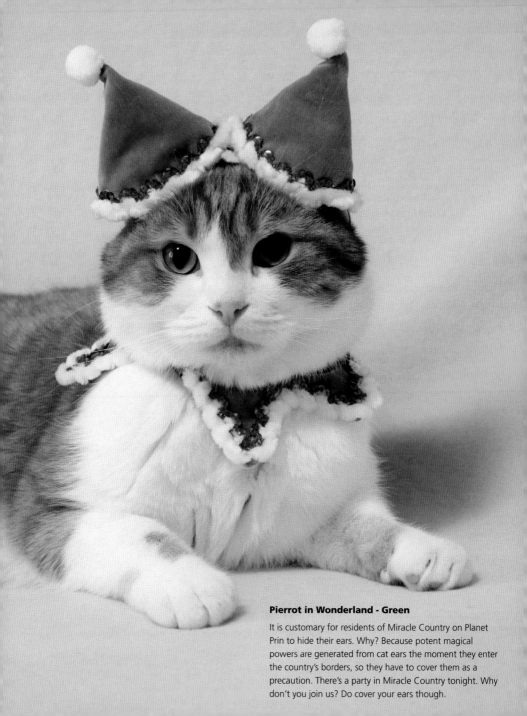

Pierrot in Wonderland - Green

It is customary for residents of Miracle Country on Planet Prin to hide their ears. Why? Because potent magical powers are generated from cat ears the moment they enter the country's borders, so they have to cover them as a precaution. There's a party in Miracle Country tonight. Why don't you join us? Do cover your ears though.

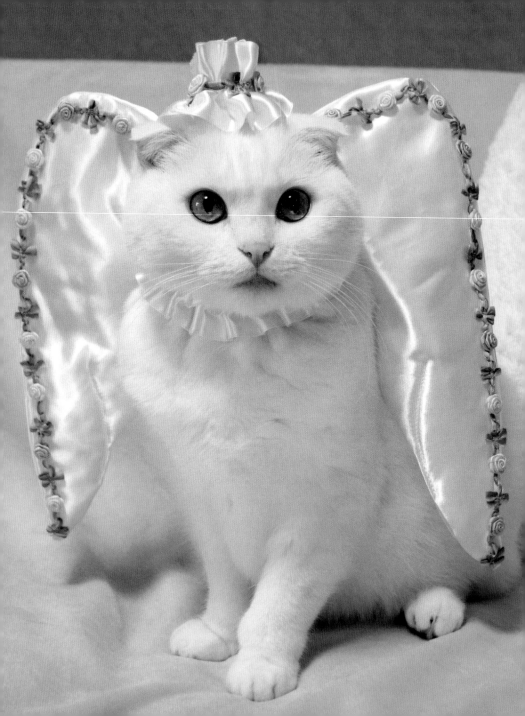

Prin's

♥ Happy ♥ Wedding

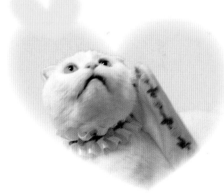

White Angel

A white angel comes to Planet Prin once a year. The white angel is an angel of love. Her great affection makes everybody happy. Look! Princess Prin is sending out love energy beams!

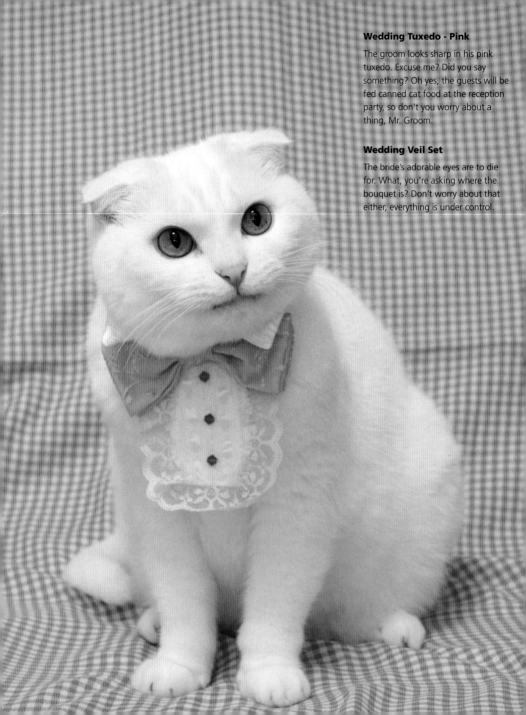

Wedding Tuxedo - Pink

The groom looks sharp in his pink tuxedo. Excuse me? Did you say something? Oh yes, the guests will be fed canned cat food at the reception party, so don't you worry about a thing, Mr. Groom.

Wedding Veil Set

The bride's adorable eyes are to die for. What, you're asking where the bouquet is? Don't worry about that either, everything is under control.

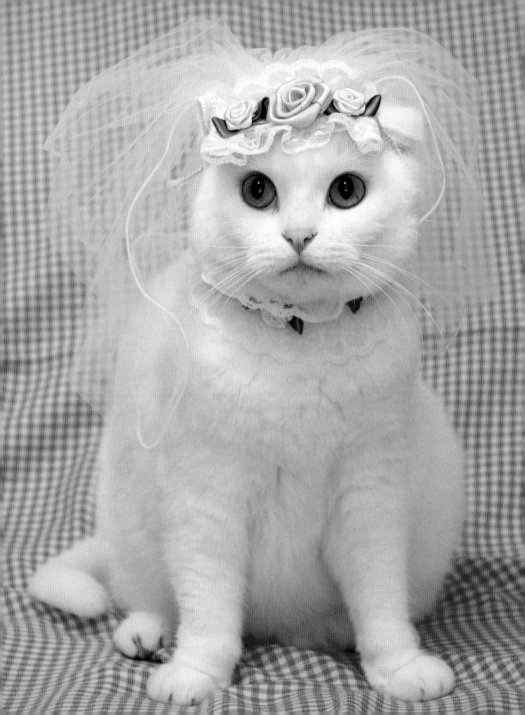

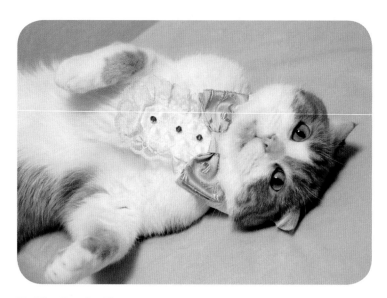

Wedding Tuxedo - Blue

Aren't you ready yet?! Why is the bride taking so looooong? I'm tired…I don't want to play Mr. Groom anymore!

The Bride's Speech

Father, Mother, I'm getting married today. Thank you for being such loving parents. I may have grown up, but I still cherish our time together. I'll miss you. I promise I'll be the happiest bride ever.

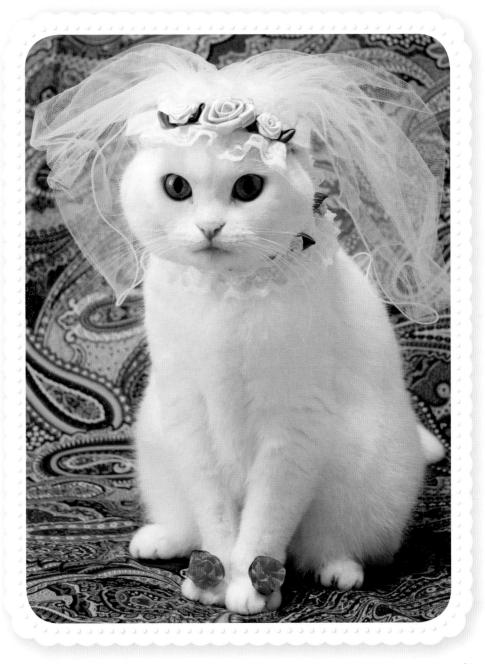

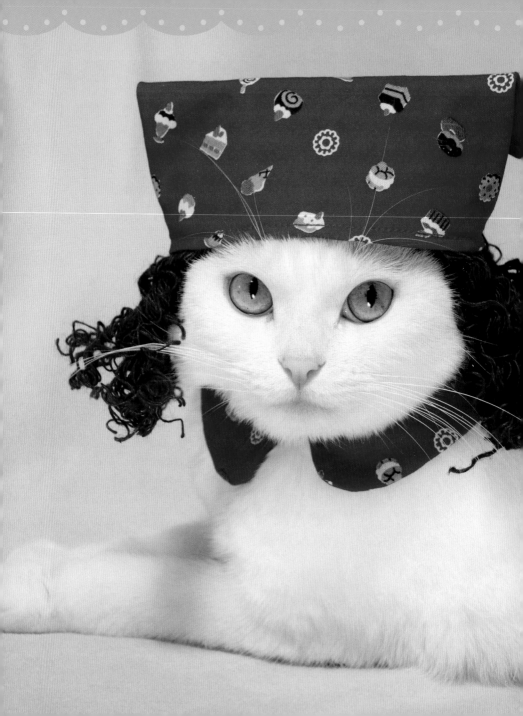

Anne of Green Gables Is Cleaning ♪

Anne of Green Gables is always teased for her "weird" frizzy red hair. Her classmates make her do all the cleaning at school. "I'm not going to give in though. Besides, Mama always compliments my frizzy red hair. She says it's cute. Plus, I'm the best at cleaning, you know!"

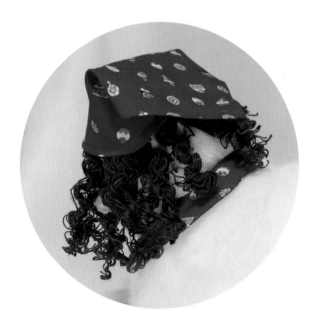

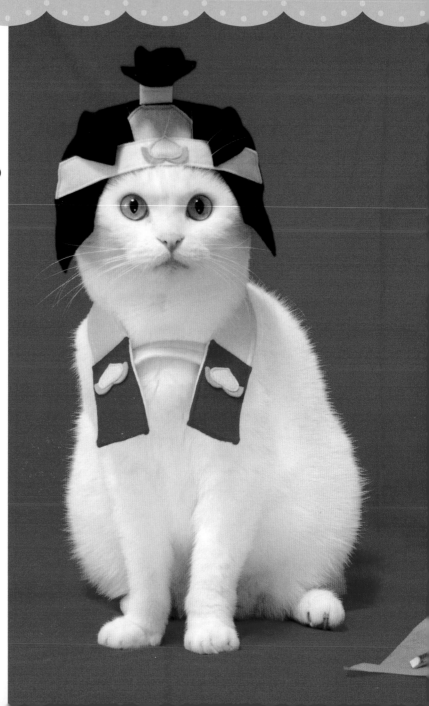

● キャスト

〈桃太郎〉
プリン、幸太郎
(ダブルキャスト)
〈お猿にゃん〉
プリン
〈犬にゃん〉
プリン
〈キジにゃん〉
幸太郎
〈緑オニにゃん〉
幸太郎
〈青オニにゃん〉
プリン
〈赤オニにゃんA・
B〉
幸太郎(二役)

● **Cast**

Momotaro
Prin, Kotaro
(double cast)

Monkey
Prin

Dog
Prin

Pheasant
Kotaro

Green Ogre
Kotaro

Blue Ogre
Prin

Red Ogre A/B
Kotaro (double
role)

The Adventures of Momotaro (Peach Boy)

♪ Momotaro-cat, Momotaro-cat, Please give me a dumpling from the bag on your waist ♪

> I'm going to hunt the ogres! Anybody who accompanies me will get a dumpling in return.

> Let me accompany you!

> Please take me to the hunt too.

> Mmm, dumplings! Yummy yummy…

良し！
OKAY!

良し！
OKAY!

> A…hen? Aren't you supposed to be a pheasant? Oh well.

> I want to go too.

Prin
Unofficial cast member

> Prin? You too? Promise not to get scared of the ogres and run away.

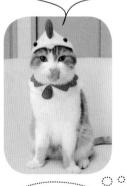

47

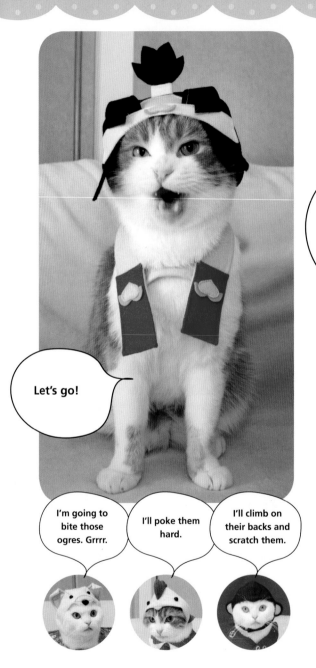

They triumphantly make their way...

Come out you ogres wreaking havoc on the townspeople!
Oh, there they are!
Attaaack!

Let's go!

I'm going to bite those ogres. Grrrr.

I'll poke them hard.

I'll climb on their backs and scratch them.

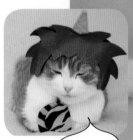

Waaa!
I surrender.

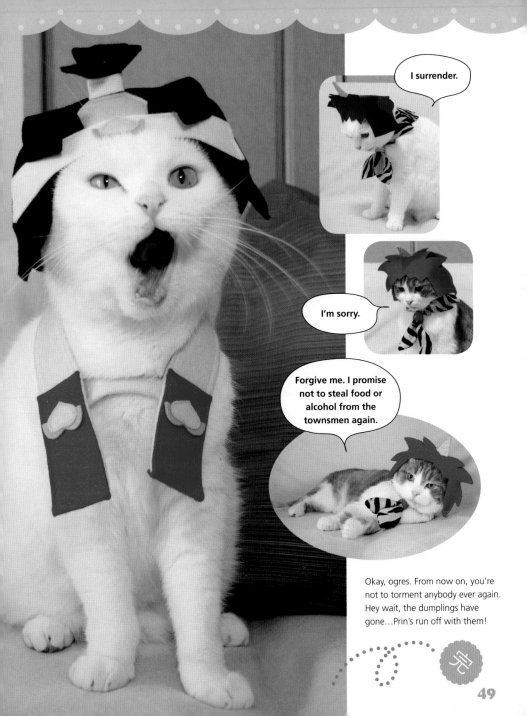

I surrender.

I'm sorry.

Forgive me. I promise not to steal food or alcohol from the townsmen again.

Okay, ogres. From now on, you're not to torment anybody ever again. Hey wait, the dumplings have gone…Prin's run off with them!

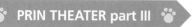
Kintaro and His Fish-shaped Bean Curd Pancake

Hey there Kintaro, since you successfully took that big bear down, I've prepared a little treat. One big, whole fish! Eat it up! ♪

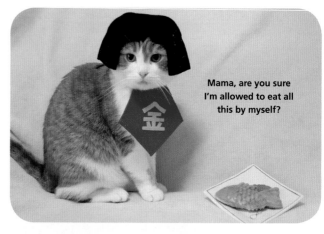

Mama, are you sure I'm allowed to eat all this by myself?

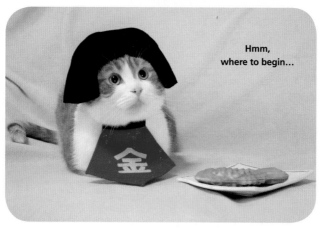

Hmm, where to begin...

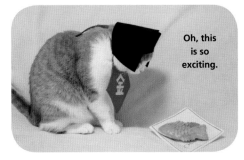

Oh, this is so exciting.

Kintaro Cat in a Flash

Transform your cat into Kintaro ("Golden boy," a Japanese folklore hero who fights a bear) in a flash with this red bib (inscribed with the Chinese character for "gold") and hat. The hat just sits on the head without any reinforcements, so watch out—the hat might disappear in a flash too!

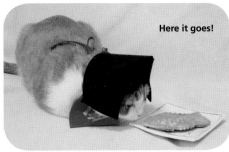

Here it goes!

ガブリ！
(Munch!)

パク
パク
(yum yum)

え?
(Huh?)

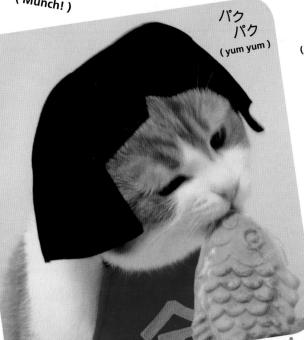

"Prin-dressed-as-Kintaro, do you want a fish too?"

"That's not a fish. It's a fish-shaped pancake! I only eat authentic cuisine."

"Okay, okay. I'll get you a real fish then."

おわり
(The End)

51

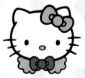

Hello Kitty Transformation Kit

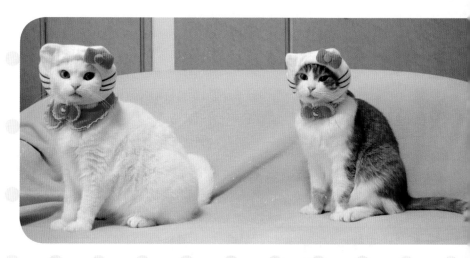

The world's first Hello Kitty item for cats, created in collaboration with Sanrio Co., Ltd. I, Prin Mama, am honored to have been able to design this product for the hugely popular Hello Kitty series. The kit comes with a Hello Kitty hat, a blouse, a choker, and a dotted pink bag. The logo of Hello Kitty wearing a blouse was designed especially for this collaboration between Hello Kitty and Cat Prin. Cute, isn't it?

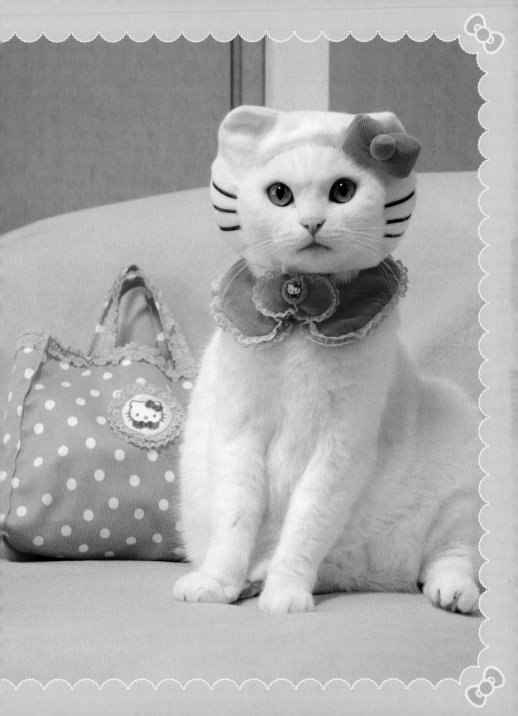

Refreshing Summer Collection

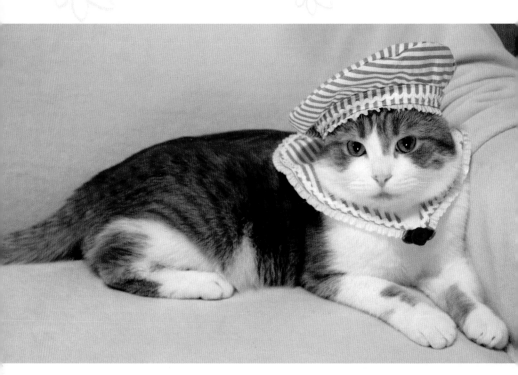

Pierre's Beret and Sailor Suit

This outfit was designed based on my image of young French boys. The beret especially looks cute when slanted like so. Pierre Kotaro, are you sleepy? What, you're tired because you studied too hard? Not in a million years!

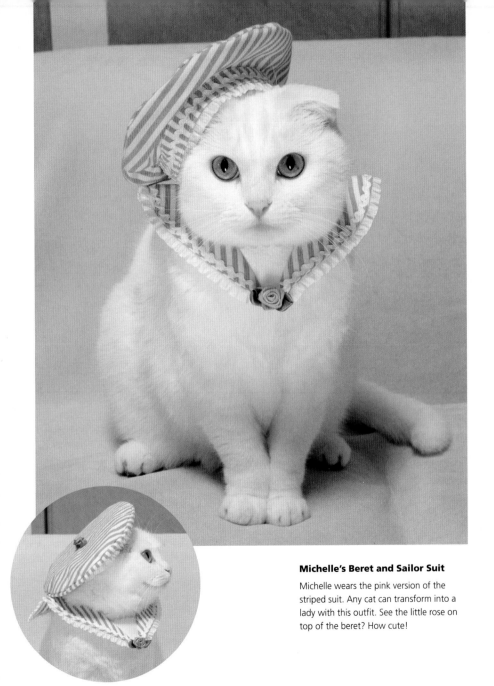

Michelle's Beret and Sailor Suit

Michelle wears the pink version of the striped suit. Any cat can transform into a lady with this outfit. See the little rose on top of the beret? How cute!

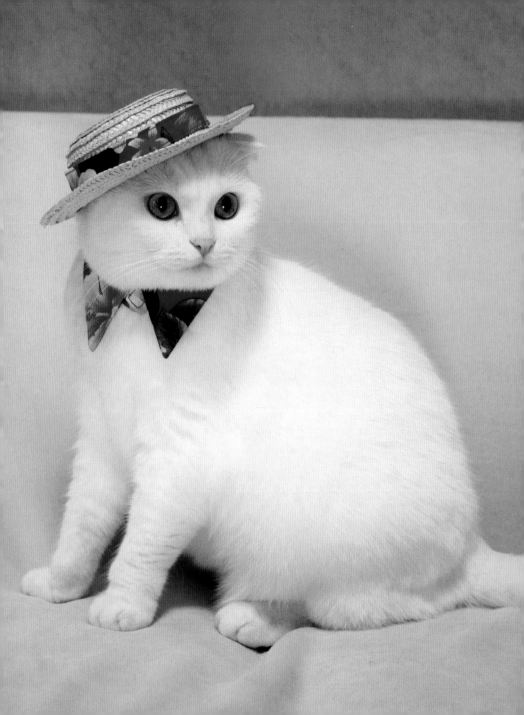

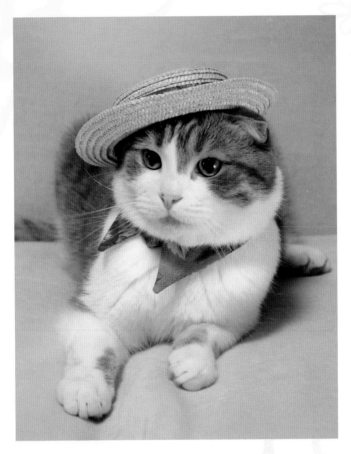

Aloha Shirt and Straw Boater Set - Red

Stay cool in the summer with this aloha shirt and boater!! Wear the boater at an angle like a fashionista. You'll be the most popular cat around! Let the aloha spirit keep you happy during those hot summer days.

Aloha Shirt and Straw Boater Set - Blue

"Mama, I want to go to Hawaii this summer! I'm definitely going. I'll go to Waikiki beach and get a tan! And I'll share a delicious can of cat food with a cute girl."

"I think you're too hairy to get a tan, Kotaro."

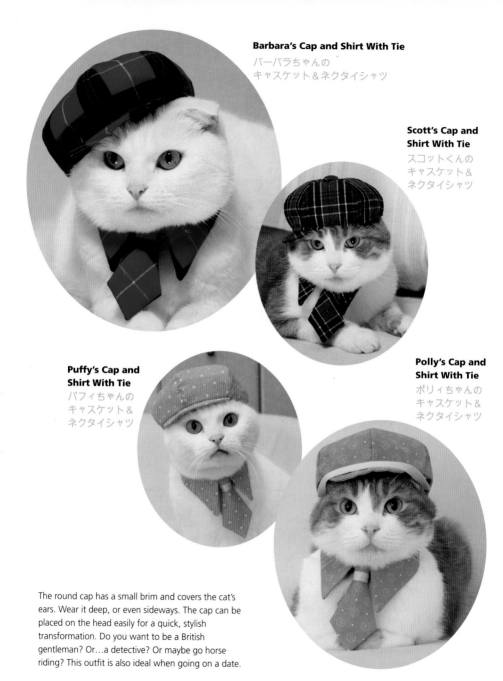

Barbara's Cap and Shirt With Tie
バーバラちゃんの
キャスケット＆ネクタイシャツ

**Scott's Cap and
Shirt With Tie**
スコットくんの
キャスケット＆
ネクタイシャツ

**Puffy's Cap and
Shirt With Tie**
パフィちゃんの
キャスケット＆
ネクタイシャツ

**Polly's Cap and
Shirt With Tie**
ポリィちゃんの
キャスケット＆
ネクタイシャツ

The round cap has a small brim and covers the cat's
ears. Wear it deep, or even sideways. The cap can be
placed on the head easily for a quick, stylish
transformation. Do you want to be a British
gentleman? Or…a detective? Or maybe go horse
riding? This outfit is also ideal when going on a date.

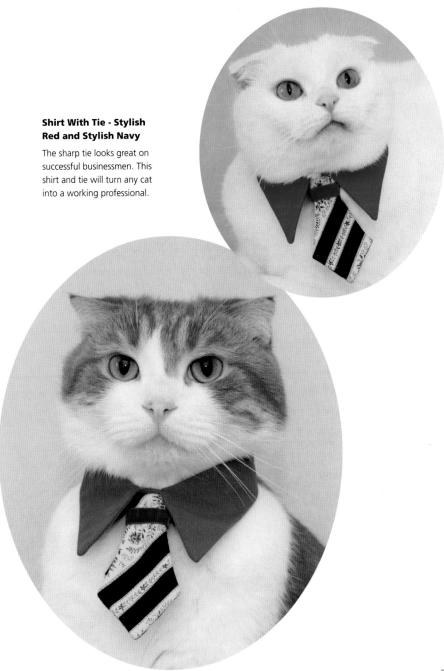

Shirt With Tie - Stylish Red and Stylish Navy

The sharp tie looks great on successful businessmen. This shirt and tie will turn any cat into a working professional.

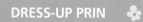
Elegant Fall/Winter Collection

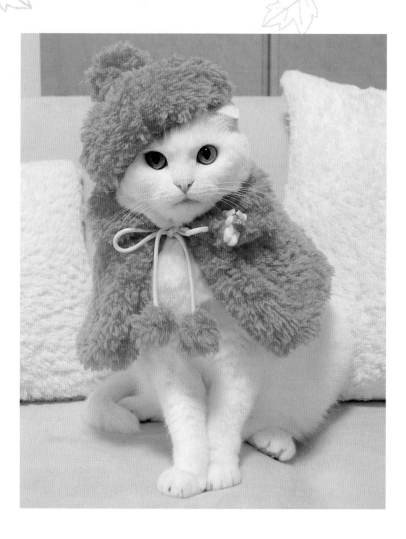

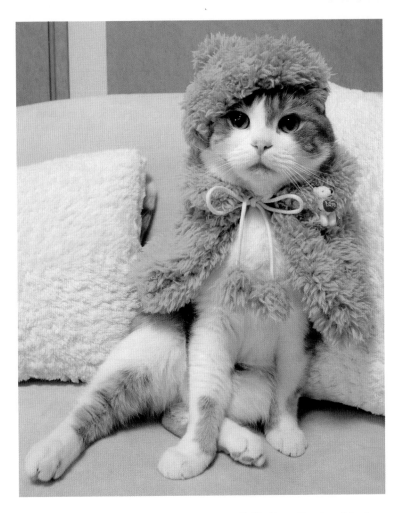

Fluffy Orange Beret and Coat

The vivid orange color will make you giddy. The poodle fleece feels amazing to the touch, both for you and your cat. In fact, so good that your cat will definitely have a knead or two. On the collar is a miniature bear hugging a heart. Oh look, there's Prin's supermodel pose! Fantastic shot!

Fluffy Green Beret and Coat

"Hey Kotaro, what's your right leg doing all the way out here?"

"Huh? Oh this leg? I'm a professional model, Mama. This is all calculated."

"Oh, really…"

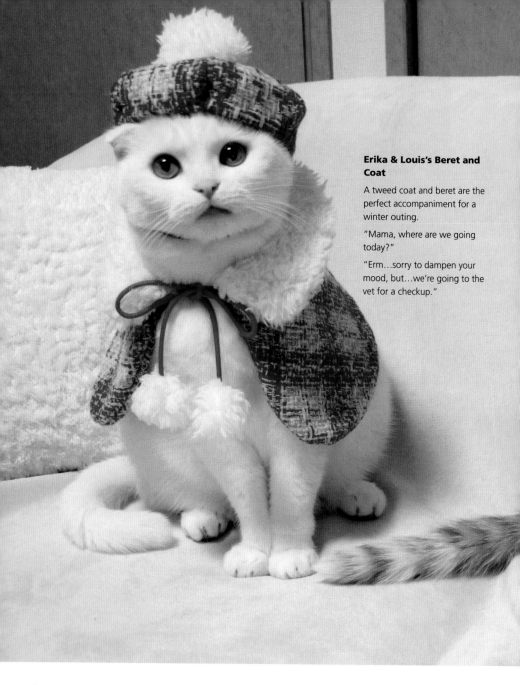

Erika & Louis's Beret and Coat

A tweed coat and beret are the perfect accompaniment for a winter outing.

"Mama, where are we going today?"

"Erm…sorry to dampen your mood, but…we're going to the vet for a checkup."

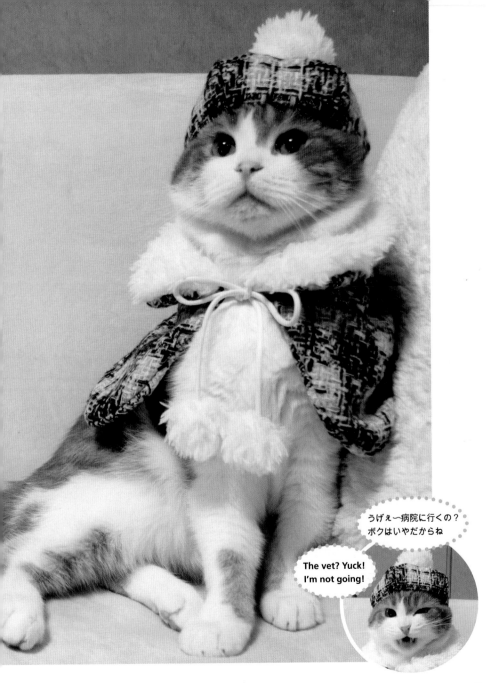

うげぇ〜病院に行くの？
ボクはいやだからね

The vet? Yuck!
I'm not going!

Elizabeth, the British Socialite

Where are you going today, Prin?

"I'm going to ride a plane to Grandmama Prin's house in Hokkaido. I'm ready to go now. Posthaste, Mama!"

Prin is perfectly comfortable riding planes, trains, and cars. She loves to play in Grandmama Prin's garden. She can't wait to get there.

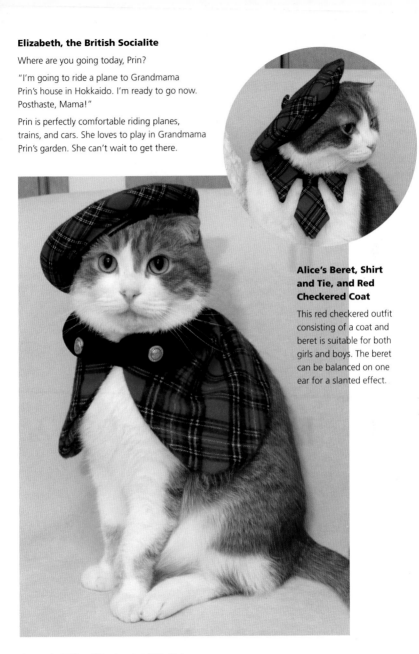

Alice's Beret, Shirt and Tie, and Red Checkered Coat

This red checkered outfit consisting of a coat and beret is suitable for both girls and boys. The beret can be balanced on one ear for a slanted effect.

左ページの写真、プリンちゃんのお顔・実寸
(Left page: Prin's face shown in actual size)

65

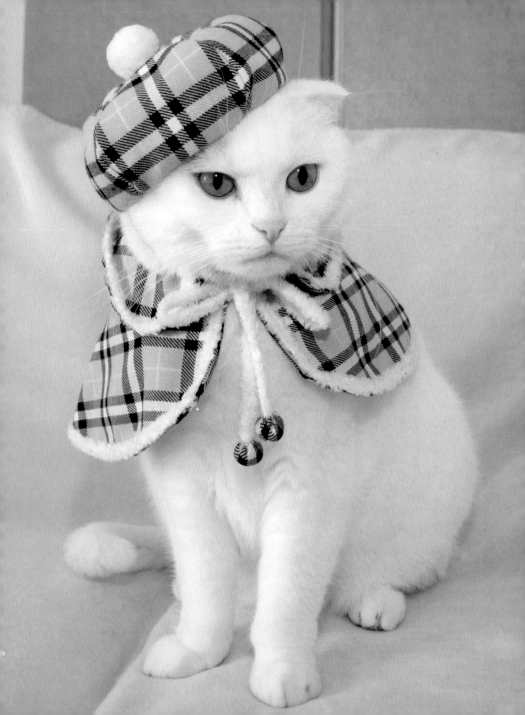

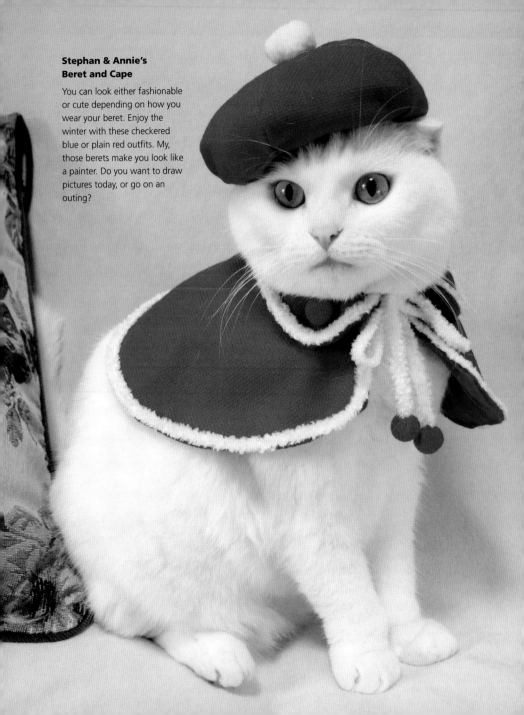

Stephan & Annie's Beret and Cape

You can look either fashionable or cute depending on how you wear your beret. Enjoy the winter with these checkered blue or plain red outfits. My, those berets make you look like a painter. Do you want to draw pictures today, or go on an outing?

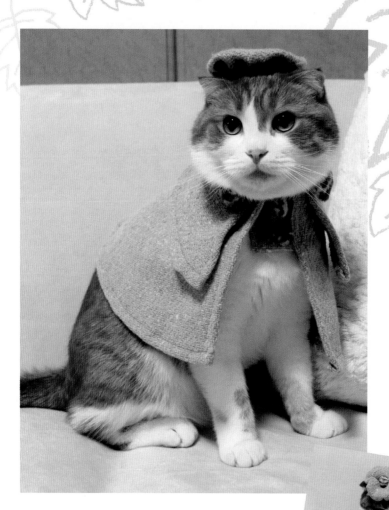

British Lady & Gentleman
Alfred & Rebecca

A coat with a double collar in green or orange tweed.

"Mama, please call me Sherlock Holmes for today."

"Why, Alfred Kotaro?"

"Because I'm going to solve lots of unsolved mysteries."

"Yes, but Kotaro, you can't solve anything if you're falling asleep like that all the time."

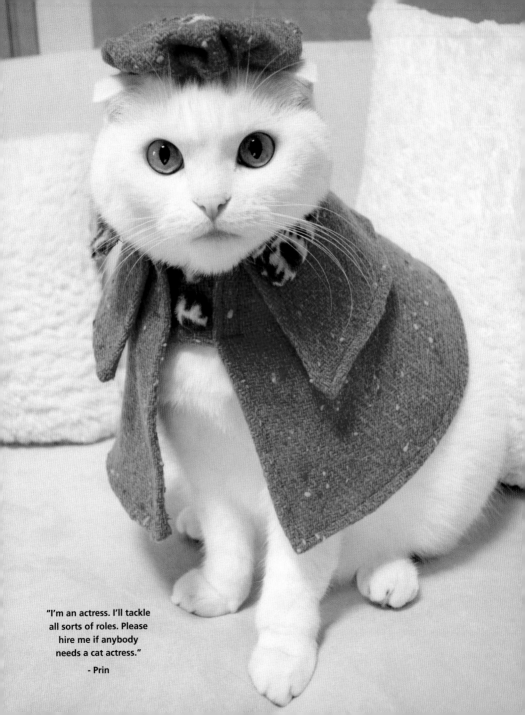

"I'm an actress. I'll tackle all sorts of roles. Please hire me if anybody needs a cat actress."

- Prin

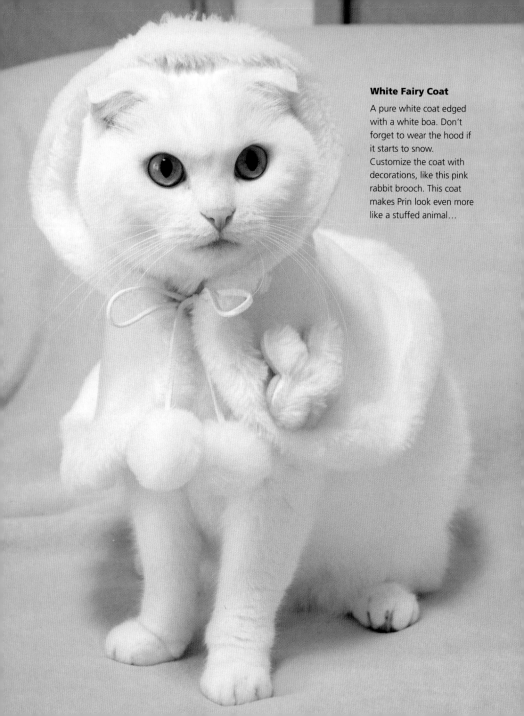

White Fairy Coat

A pure white coat edged with a white boa. Don't forget to wear the hood if it starts to snow. Customize the coat with decorations, like this pink rabbit brooch. This coat makes Prin look even more like a stuffed animal…

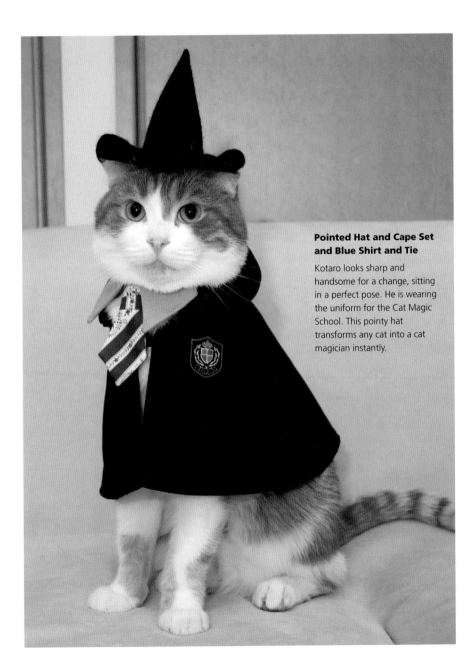

Pointed Hat and Cape Set and Blue Shirt and Tie

Kotaro looks sharp and handsome for a change, sitting in a perfect pose. He is wearing the uniform for the Cat Magic School. This pointy hat transforms any cat into a cat magician instantly.

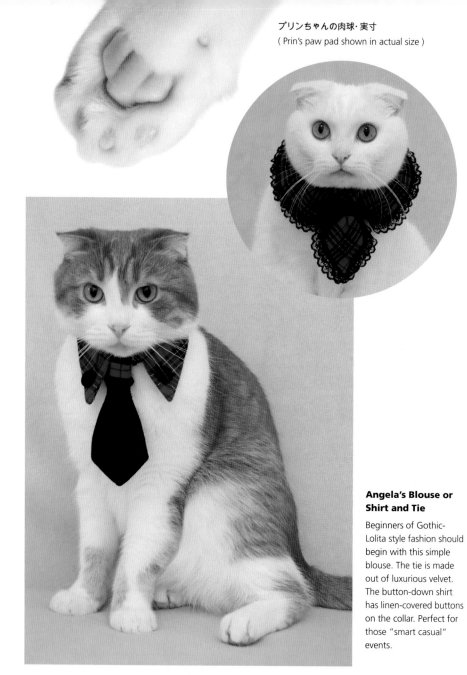

プリンちゃんの肉球・実寸
(Prin's paw pad shown in actual size)

Angela's Blouse or Shirt and Tie

Beginners of Gothic-Lolita style fashion should begin with this simple blouse. The tie is made out of luxurious velvet. The button-down shirt has linen-covered buttons on the collar. Perfect for those "smart casual" events.

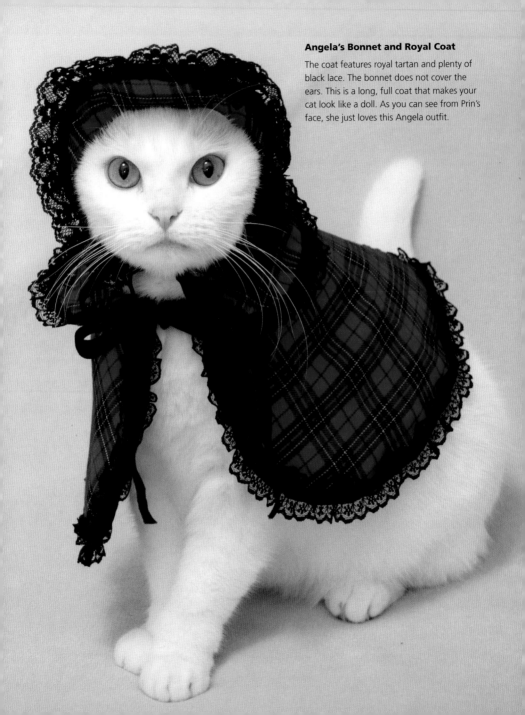

Angela's Bonnet and Royal Coat

The coat features royal tartan and plenty of black lace. The bonnet does not cover the ears. This is a long, full coat that makes your cat look like a doll. As you can see from Prin's face, she just loves this Angela outfit.

Prin Doll & Fair Lady

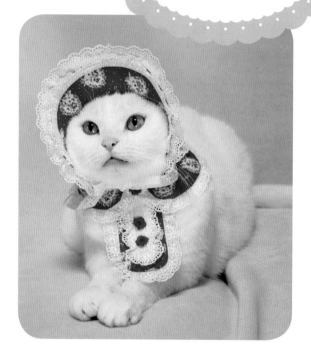

Anne-Marie's Bonnet and Frilled Blouse

Prin Mama was excited when she found this lace material because it was exactly what she had envisioned for this outfit. The blouse is decorated with red organdy roses for a summery look.

"Prin, how your eyes shine bright. Are you really a cat? You must be gazing across the universe at Planet Prin."

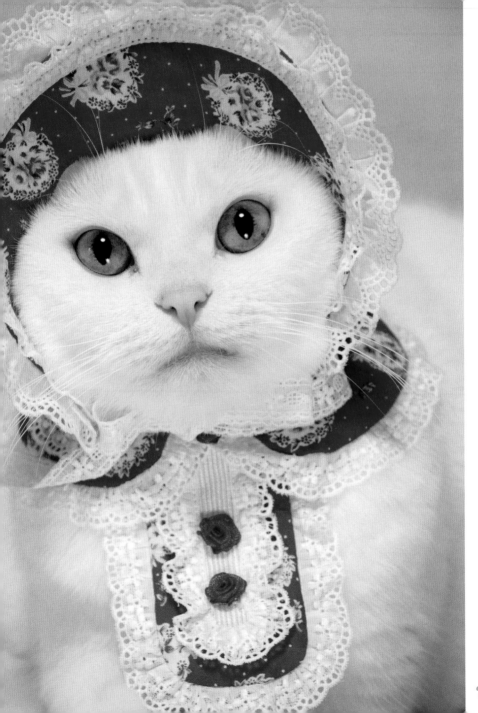

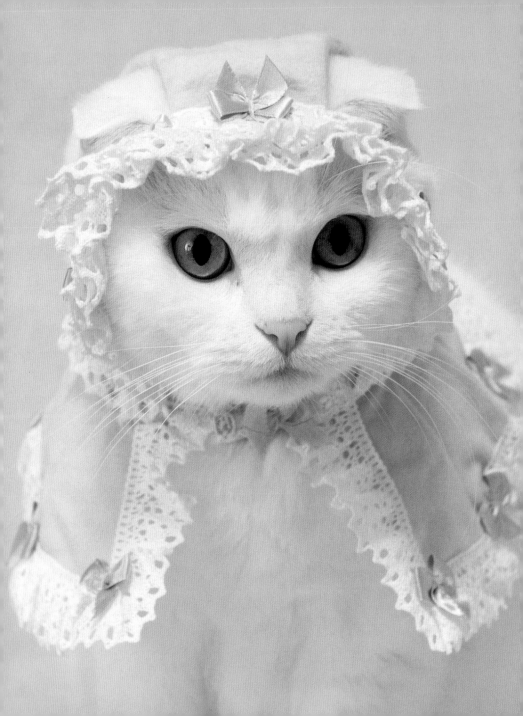

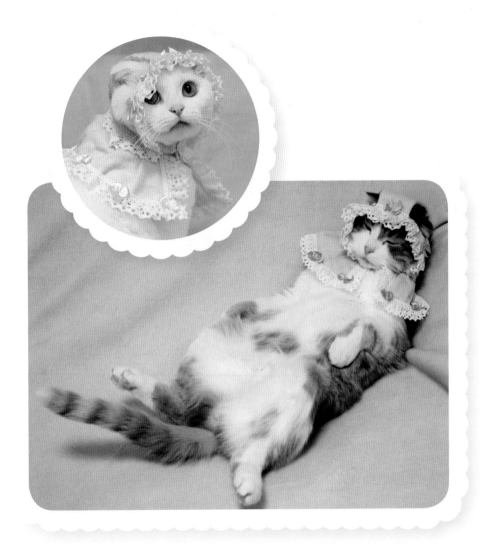

Francois and Marietta's Bonnet and Cape

This frilly outfit is made from cotton flannel and torchon lace. Planet Prin natives wear this when they feel like being a kitten again.

Francois Kotaro, please wake up, we're in the middle of a shoot! Oh dear, he's actually turned into a baby. Good night. Sweet dreams.

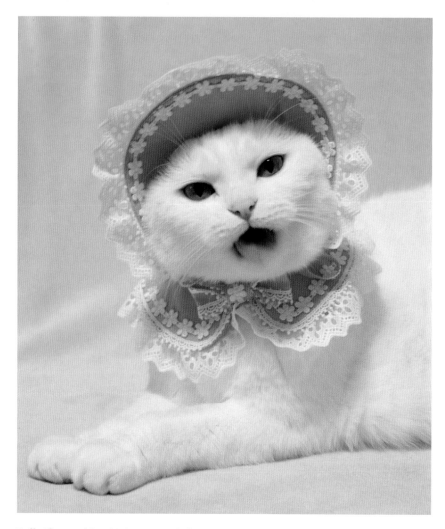

Dolls Clara and Sarah's Bonnet and Blouse

Three types of outfits featuring white lace to make your cat look like a doll.

"Oh my, Prin, please put your tongue away."

Even the playful Kotaro looks like an adorable doll in this outfit.

"Mama, why do you want to dress me up like a baby?"

"Well, it's because you act like one."

"No, I don't! I have profound thoughts too, you know. Like, how my canned cat food tasted especially good today…"

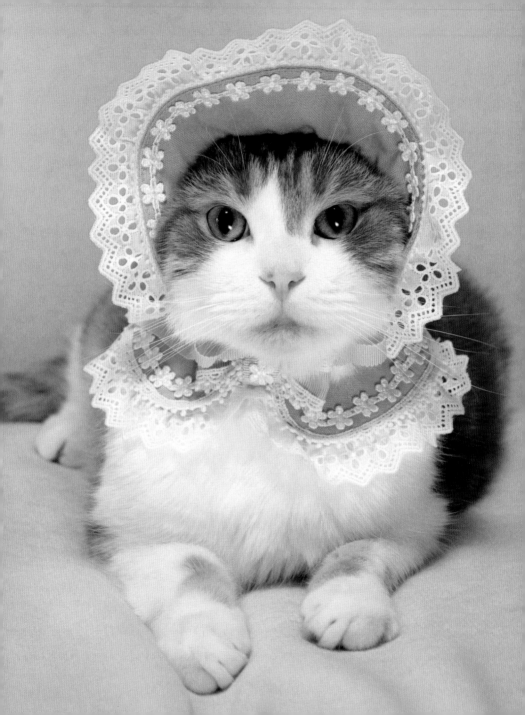

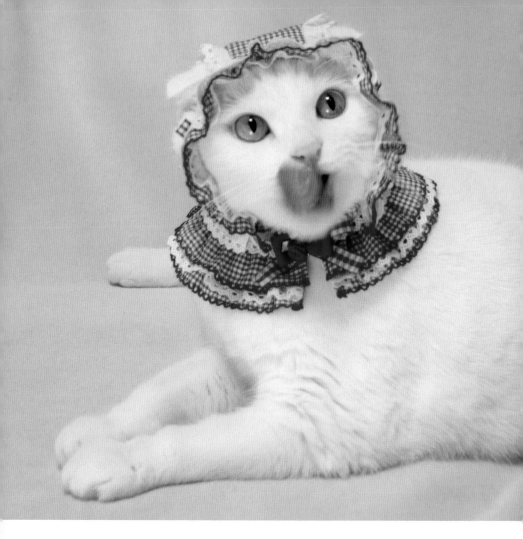

Emily and Becky's Bonnet and Blouse

The first ever Gothic-Lolita style outfit by Cat Prin with a high-quality finish. The blouse is made out of four layers of lace. Your cat will love this bonnet, as it doesn't cover the ears. This is one of Prin Mama's favorite outfits too.

"Oh dear, Prin, you're at it with your tongue again. Young ladies shouldn't stick their tongues out like that."

"Mama, can I have my snack now?"

"No, Prin, we're still working, remember? Oh, and Kotaro, please smile at the camera."

"But why do I have to always dress up as a girl?!"

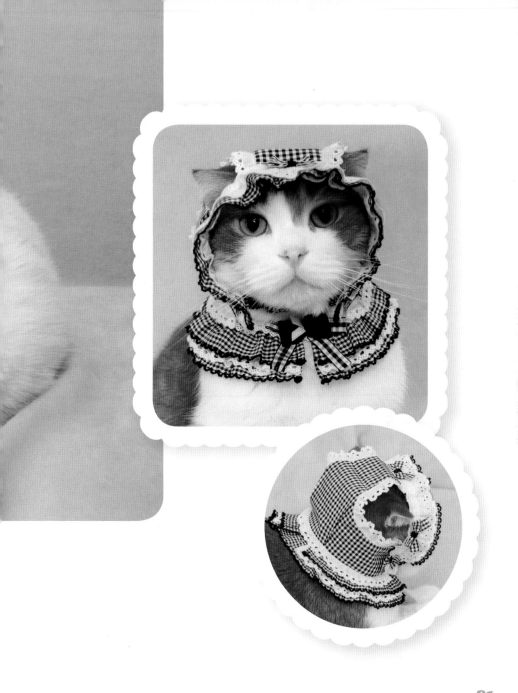

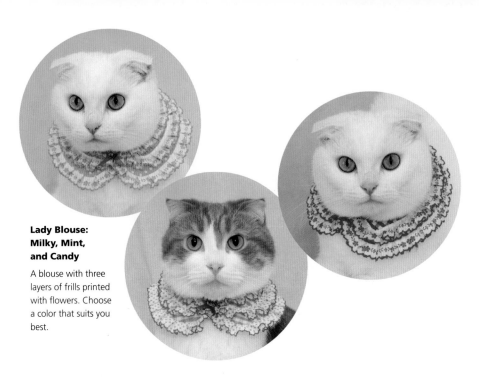

Lady Blouse: Milky, Mint, and Candy

A blouse with three layers of frills printed with flowers. Choose a color that suits you best.

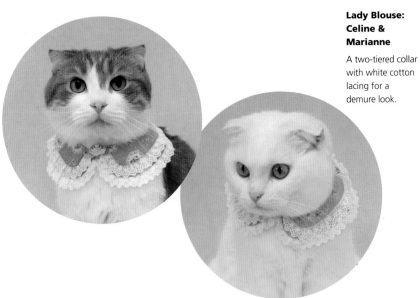

Lady Blouse: Celine & Marianne

A two-tiered collar with white cotton lacing for a demure look.

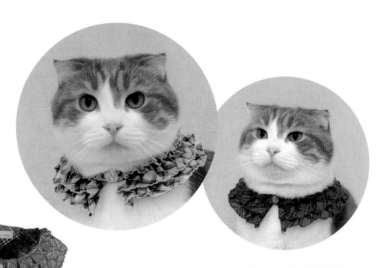

Lady Blouse:
Rudy & Maggie

Both girls and boys on Planet Prin wear blouses.

"Kotaro, please try to look more effeminate since you're modeling the Lady Blouse."

"But Mama! Seriously! Why am I always dressed like a girl?"

"Like I told you, it's because you're so cute. Now, smile at the camera."

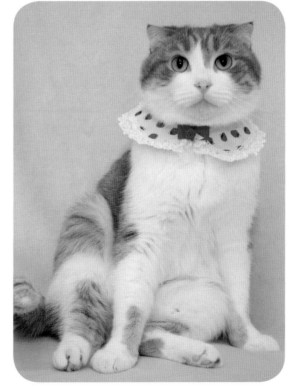

Lady Blouse: Strawberries on Yellow

A cute blouse with red strawberries on a creamy yellow background.

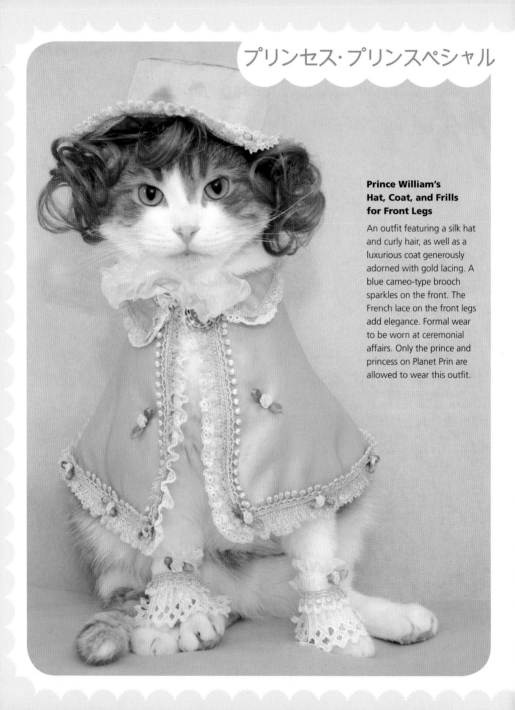

Prince William's Hat, Coat, and Frills for Front Legs

An outfit featuring a silk hat and curly hair, as well as a luxurious coat generously adorned with gold lacing. A blue cameo-type brooch sparkles on the front. The French lace on the front legs add elegance. Formal wear to be worn at ceremonial affairs. Only the prince and princess on Planet Prin are allowed to wear this outfit.

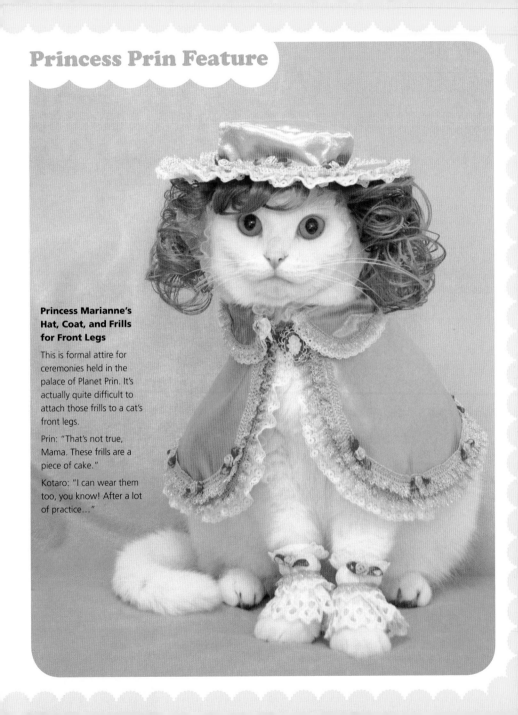

Princess Prin Feature

Princess Marianne's Hat, Coat, and Frills for Front Legs

This is formal attire for ceremonies held in the palace of Planet Prin. It's actually quite difficult to attach those frills to a cat's front legs.

Prin: "That's not true, Mama. These frills are a piece of cake."

Kotaro: "I can wear them too, you know! After a lot of practice…"

Diary entry 1: Fantastic weather today.
Prin loves this weather. She also loves
grooming. Today, we got out her
grooming set and brushed her teeth. Prin
can brush her teeth all by herself: When I
place the end of a Q-tip on the edge of
her mouth, she proceeds to clean her
teeth with it in a chewing motion. Next,
we trimmed her nails, and used two kinds
of brushes to brush her hair. She can
brush herself too: I simply place the brush
onto her cheek, and she automatically
drags her face on it. Finally, I always use
lotion when cleaning her pink paw pads.

美人さんの完成♪
(All groomed and pretty♪♪)

Diary entry 2: "Mama, hurry, hurry!
You're taking too long, I'm
hungry!" "Sorry, dears, please
wait while I clean the tray and
your bowls." Kotaro rushes Mama
for his food everyday. As Prin
Mama shouts, "Meal time!" both
cats run to their positions. Prin can
stand on her two hind legs, but
Kotaro needs to lean on the wall
to support himself as he cranes his
neck to get a better view of his
dinner. Funny, aren't they?

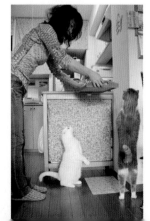

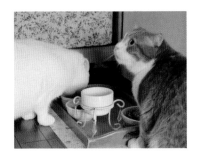

As Prin Mama says, "You can start now," both cats begin to eat their food hungrily.

Diary entry 3: Kotaro calls Prin Mama from the top of a cardboard box. "Mama, I can't get down! Carry me." When Prin Mama pats her left shoulder, Kotaro jumps onto her for a cuddle and climbs onto her shoulders. This is one of the secret sign languages that only Kotaro and Prin Mama understand.

Diary entry 4: Kotaro snuggles up to Prin Mama yet again today. When Prin Mama asks, "Who wants a snack?" Kotaro puts a front paw up as if to say, "Me, me!" He then strokes Prin Mama's cheek and mouth with his paw. Aw, heaven.

「ボク、おんぶも好きなんだ」
("I like being piggy-backed too.")

Diary entry 5: It's Prin's birthday today! She's a grand ten years old. I made a special cake for her. She insisted on blowing the candles out herself, and she was careful not to singe her whiskers. Happy birthday, Prin!

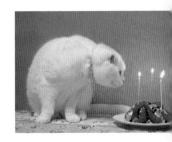

〈 プリンのサイズ 〉

<Prin's Size>

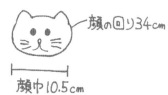

顔の回り34cm

顔巾10.5cm

Circumference of face: 34 cm
Diameter: 10.5 cm

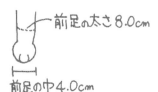

前足の太さ8.0cm

前足の巾4.0cm

Circumference of front leg: 8 cm
Diameter: 4 cm

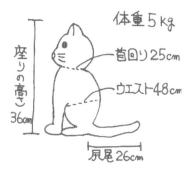

体重5kg

首回り25cm

ウエスト48cm

座りの高さ36cm

尻尾26cm

Seated height: 36 cm Weight: 5 kg
Circumference of neck: 25 cm
Waist: 48 cm Tail: 26 cm

〈 幸太郎の サイズ 〉

<Kotaro's Size>

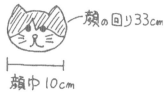

顔の回り33cm

顔巾10cm

Circumference of face: 33 cm
Diameter: 10 cm

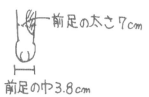

前足の太さ7cm

前足の巾3.8cm

Circumference of front leg: 7 cm
Diameter: 3.8 cm

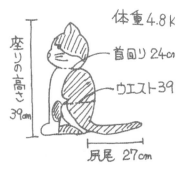

体重4.8k

首回り24cm

ウエスト39

座りの高さ39cm

尻尾 27cm

Seated height: 39 cm Weight: 4.8 kg
Circumference of neck: 24 cm
Waist: 39 cm Tail: 27 cm

イラスト:プリンママ
(Illustration: Prin Mama)

Diary entry 6: I was in the kitchen, when suddenly I turned around to see Kotaro. "Erm, Kotaro, that's my fruit basket."

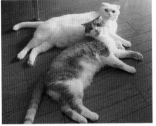

Diary entry 7: The two cats are sitting by the window. Gazing out the window together is one of their daily routines.

Diary entry 8: The two cats are being chummy today. They're even sunbathing together. "Mama, are you jealous?" "Yes! I want to join too!"

Diary entry 9: Lots of relaxing today. Kotaro snores so loud! Perhaps he's saving his energy for tomorrow's shoot? Prin is curled up in a ball, observing Prin Mama like she always does. "Prin, what are you looking at?"

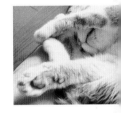

Kotaro does stretching exercises on a daily basis too. "Mama, you should exercise a bit too, you know." And what is Prin up to? Oh, there she is staring at me with a serious expression on her face again.

Diary entry 10: Today, I was interviewed by Seoul's KBS.TV at the Cats Livin store in Odaiba. During the shoot, I dressed the Cats Livin cats in my outfits. The interview will be aired in South Korea sometime soon.

(The segment was aired on October 26, 2007)

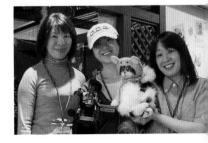

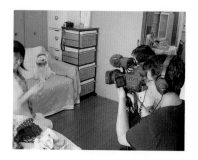

Diary entry 11: New York's VBS.TV came to our house to shoot a 15-minute video on Cat Prin! Wow! Both Prin and Kotaro put their best foot forward. Our long-awaited debut in the U.S. is finally here.

Diary entry 12: Today, we were interviewed by media from Hong Kong. Both cats have mastered cat English after meeting all of these interviewers from overseas. Or rather, maybe cat language is universal? Prin had a crush on the handsome photographer and kept chatting him up in catspeak.

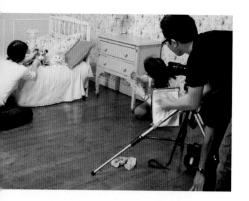

Diary entry 13: We shot a video for the "My Pets Award by Toshiba" today. The shoot took place in a studio with a set of a house built in. That was a new experience for us. We entered the studio at noon. Keiko Yamashita, the president of my agency, Karanomori, and the entire Prin family worked hard in the studio until 10 PM that evening.

We also shot a commercial for an air conditioner at the same time. Good work, guys! We arrived home at 11 PM. The staff were wonderful too. Thank you, everybody!

Diary entry 14: Prin and Kotaro graced the cover of the pet magazine *Wannyan Walker*, and I saw the finished version of a huge poster of them too. So happy.

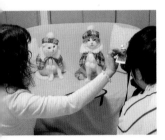

Diary entry 15: Prin loves the kind eyes of the photographer Tomokaflex, who shot this book. Today is the last day that he will be shooting them. Both Prin and Kotaro are giving it their all. What is that you say? They're just staring at the snack I'm waving in front of the camera? Anyway, it was a fun shoot.

"Prin was the perfect model. When she was in front of that camera, she didn't move a muscle and stared straight at the lens for minutes on end. I've never heard of a cat that poses for a photograph on cue. And don't forget, she's wearing clothes throughout the whole ordeal! Prin is the only cat in the world that is capable of a feat like that." (Statement by Tomokaflex)

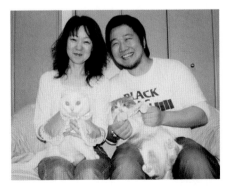

大好きなプリンママとフォトグラファー
・Tomokaflex さんに抱かれたプリンちゃんと幸太郎くん
(Prin and Kotaro being cuddled by their much loved Prin Mama and the photographer Tomokaflex.)

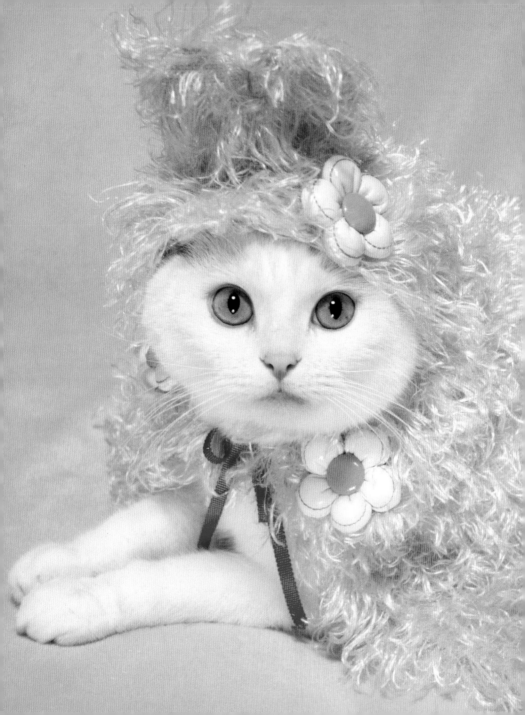

Prin's
Animal Transformation Kit

Pink Mammoth-Rabbit

This mammoth-rabbit with long pink hair is a mysterious prophet. She works day and night in Miracle Country on Planet Prin to protect the planet's future. When her eyes begin to sparkle, that's when her prophecy begins. Now, ask her what future lies ahead for you…

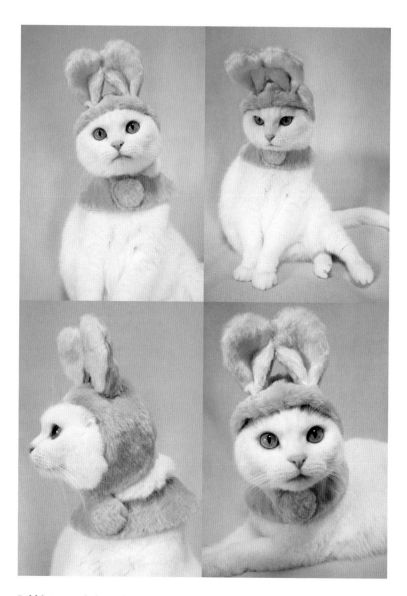

Rabbit Hat and Shawl (Pink)

Cat Prin's most popular outfit. "I'm quite fond of this pink rabbit outfit too, you know," says Prin. Apparently there aren't any white rabbits on Planet Prin, only colorful ones.

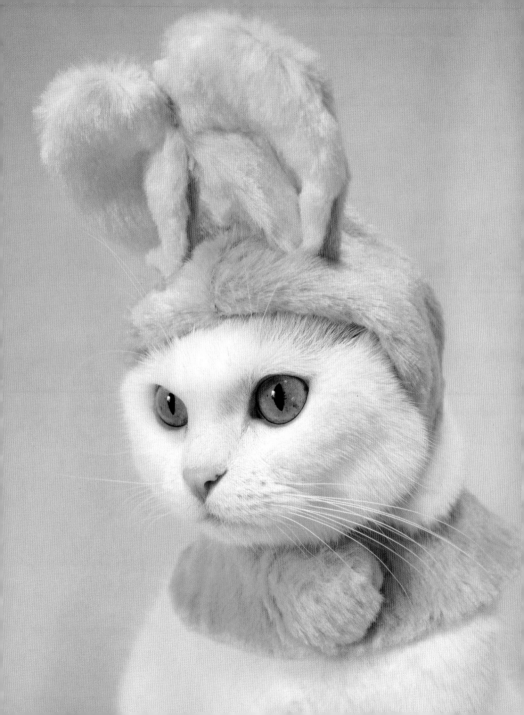

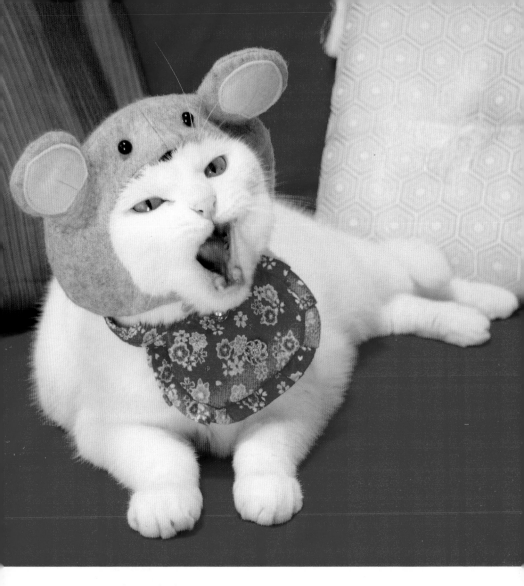

I'm a Rat, Squeak Squeak Kit

2008 was the Year of the Rat according to the Chinese calendar. New Year's cards were inundated with images of cats dressed as mice. Prin-dressed-as-rat is singing a song for us. I wonder what it is?

"Oooooh, I aaaaam a raaaaat!"

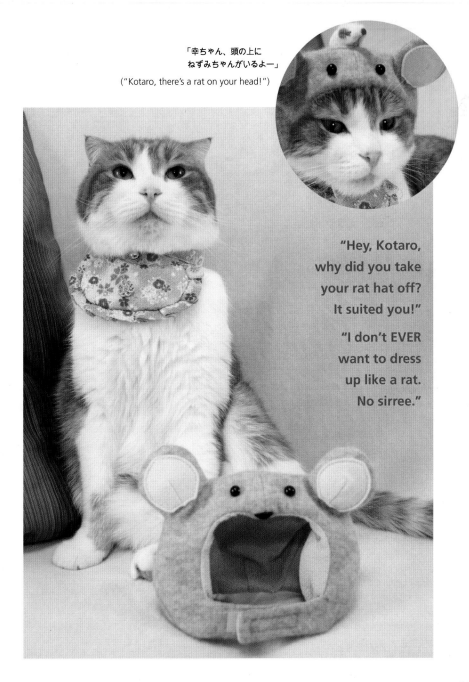

「幸ちゃん、頭の上に
ねずみちゃんがいるよー」

("Kotaro, there's a rat on your head!")

"Hey, Kotaro,
why did you take
your rat hat off?
It suited you!"

"I don't EVER
want to dress
up like a rat.
No sirree."

97

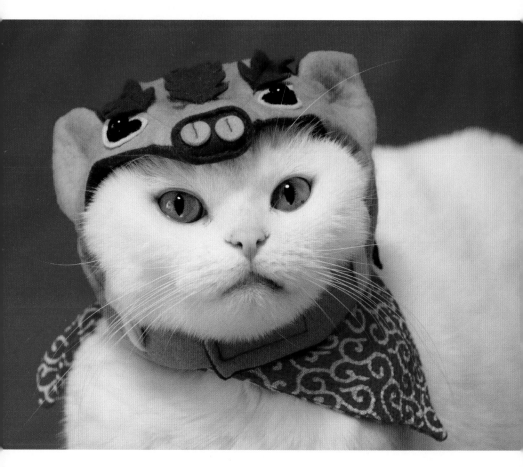

Lucky♪ Run, Boar, Run

A boar outfit for the Year of the Boar in the Chinese calendar. The design of the nose and ears is quite complicated. No doubt the year will rush past us like a lively boar.

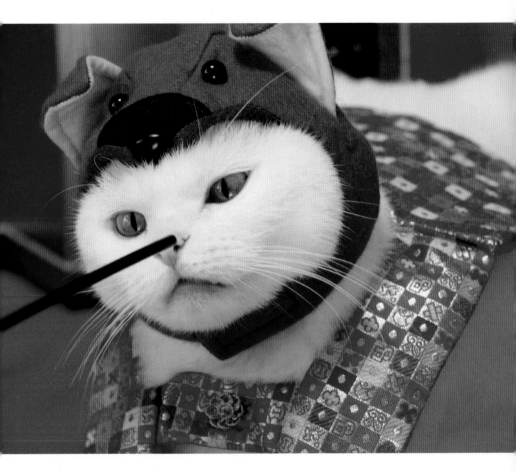

I'm a Lucky Dog, Woof! Brown Doggy Kit

A luxurious gown embroidered in gold. These outfits
have been made for all those Cat Prin fans who have
written to me saying, "I want my cat to live a long life so
that it can wear all of your Chinese Zodiac outfits." To
their health and prosperity!

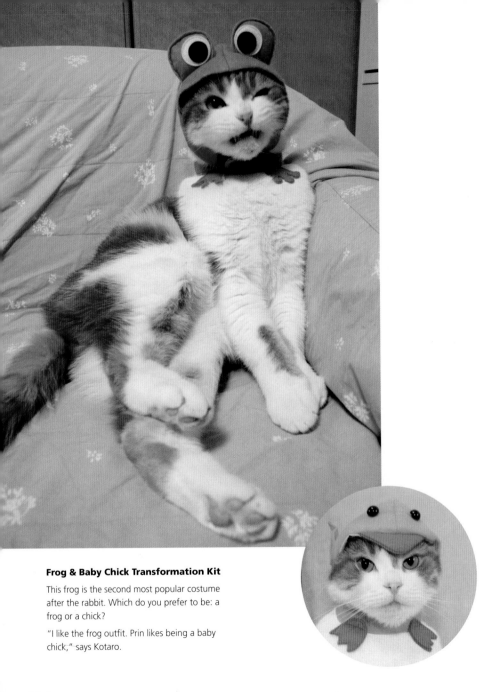

Frog & Baby Chick Transformation Kit

This frog is the second most popular costume after the rabbit. Which do you prefer to be: a frog or a chick?

"I like the frog outfit. Prin likes being a baby chick," says Kotaro.

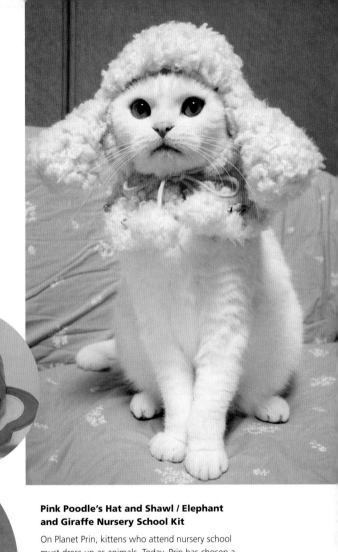

Pink Poodle's Hat and Shawl / Elephant and Giraffe Nursery School Kit

On Planet Prin, kittens who attend nursery school must dress up as animals. Today, Prin has chosen a pink poodle outfit. Kotaro always takes forever choosing which animal to be. An elephant? A giraffe? "I don't want to look like the other children!" says Kotaro.

101

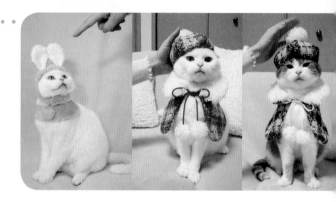

Whenever we do a shoot, I always make sure that I shower my cats with praise. Both Prin and Kotaro are required to pose in front of the camera for about an hour at a time. For the shoot today, the cats took turns from noon to 6 PM. Prin always tells me that "being a model requires perseverance."

As for Kotaro, I try to make him think that photo shoots are fun by letting him play with toys on the set.

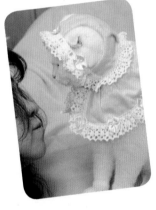

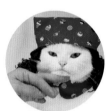

"Prin, good luck on the shoot!"

"Yes, yes, I'm ready to go. You should do your best too, Prin Mama dear."

"Okay Prin, whatever you say."

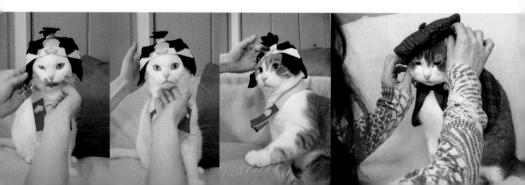

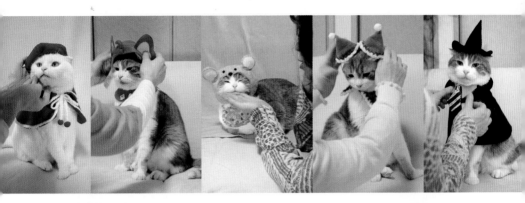

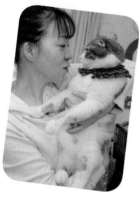

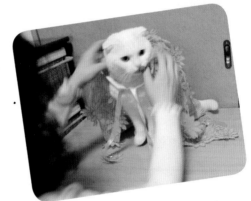

"Now, Kotaro, you and Prin Mama are going to have lots of fun working!"

"Okay, I'll try my best, Mama, but promise you'll give you lots of hugs later?" "Of course! I'll cuddle you as much as you like."

To Kotaro, work and play have no boundaries. He always has fun no matter what.

During the shoot, Prin Mama is busy doing their hair and dressing the cats all by herself. We usually use toys to make them look into the camera, but Prin likes to come up with her own poses, and looks straight into the lens without being prompted. What a pro!

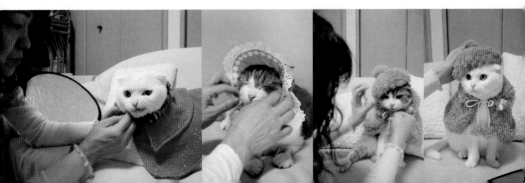

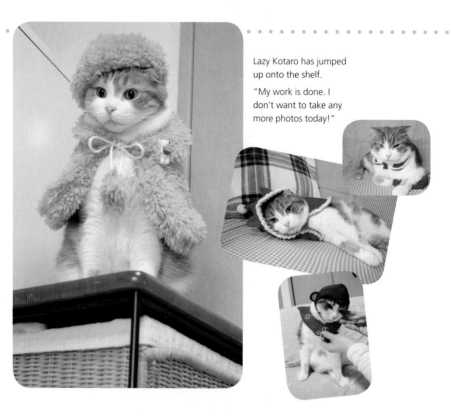

Lazy Kotaro has jumped up onto the shelf.

"My work is done. I don't want to take any more photos today!"

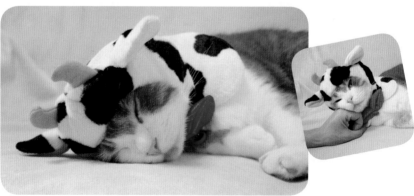

Kotaro has fallen asleep in the cow outfit.
Come on, little cow, wakey wakey! Oh well.
Here, you can use my hand as a pillow.

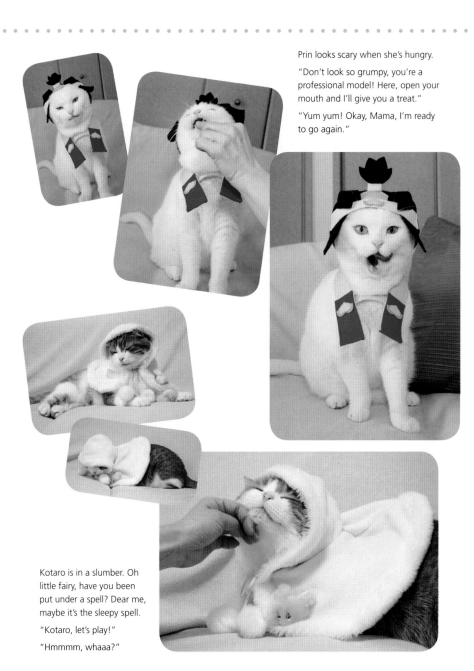

Prin looks scary when she's hungry.

"Don't look so grumpy, you're a professional model! Here, open your mouth and I'll give you a treat."

"Yum yum! Okay, Mama, I'm ready to go again."

Kotaro is in a slumber. Oh little fairy, have you been put under a spell? Dear me, maybe it's the sleepy spell.

"Kotaro, let's play!"

"Hmmmm, whaaa?"

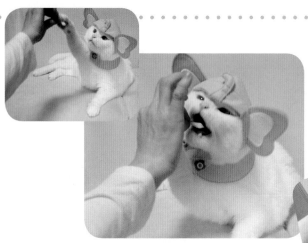

I try to boost Prin's energy with dried chicken breast fillet, or dried cat food.

"Mama, bring it closer!"

"Here, I'm putting it in your mouth. Is it yummy?" She bites into it by grabbing onto Mama's hand with both paws.

Kotaro's energy booster is jelly to help furball digestion. He loves to lick it off of the tips of Prin Mama's fingers.

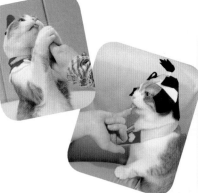

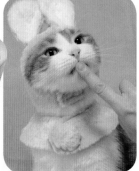

Kotaro shoves the hat off of his head.

"I don't want to be Kintaro!"

"Okay then, let's play. Boink, I win!"

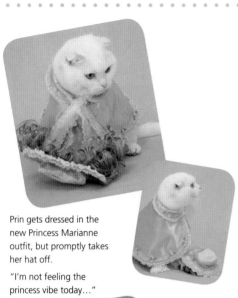

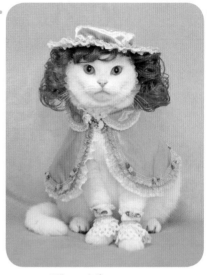

Prin gets dressed in the new Princess Marianne outfit, but promptly takes her hat off.

"I'm not feeling the princess vibe today…"

"I'll wear it if you want me to though. I'm a pro, you know."

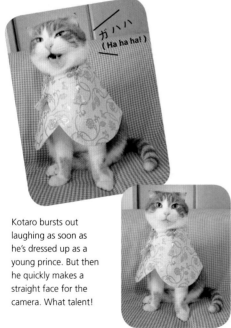

ガハハ
(Ha ha ha!)

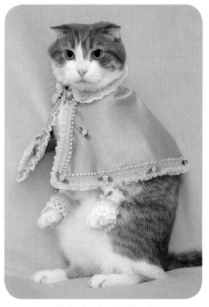

Kotaro bursts out laughing as soon as he's dressed up as a young prince. But then he quickly makes a straight face for the camera. What talent!

Oh look! Prince William is on his two hind legs!!

Cat Prin's
Cute Miscellaneous Goods

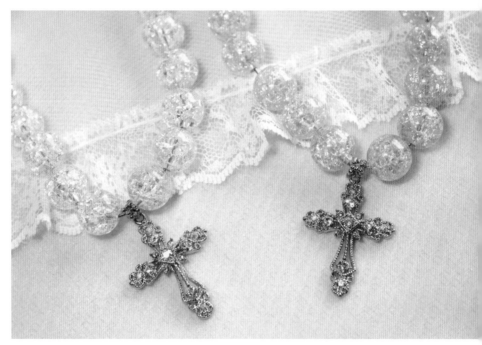

Gorgeous Beads: Marilyn & Sophie

A necklace made out of beads that sparkle like diamonds,
decorated with a gold cross. Wear this when entertaining
guests or attending a party.

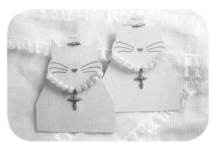

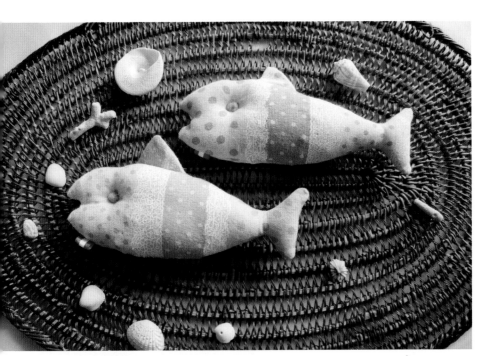

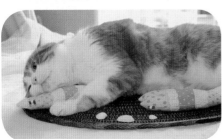

Our Favorite Cat Toy

Both Prin and Kotaro adore this "Silver Vine Poisson" available via the Le Chat Store and Cat Prin. I shot the poisson among some seashells because they were so pretty, but then…Kotaro came and drooled on everything!

(Note: silver vine is known to have a similar effect on cats as catnip.)

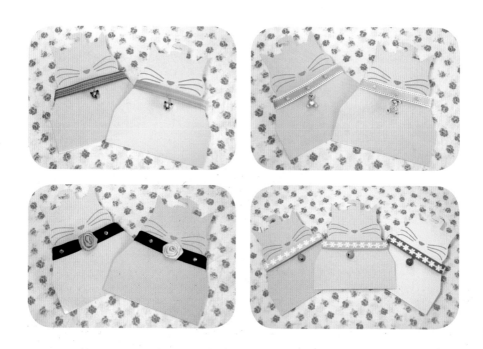

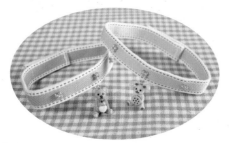

Choker

Beginners should take the first step to being a style whiz by trying some simple chokers. These can be fastened easily with Velcro, and yet they add a lovely touch to your daily outfits.

How to Make a Choker for Your Cat

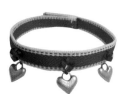

💜 **What to prepare**

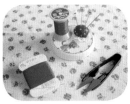

💜 **Materials**

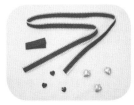

- Scissors
- Sewing pin, dress pin
- Thread to sew with (same color as ribbon)
- Sewing-machine thread if using a sewing machine

Your choice of adornments (hearts, flowers, beads, etc.)

One 65 cm piece of ribbon

Velcro (approx. 4 cm x 1 cm)

💜 **Method**

❶ Fold the ribbon

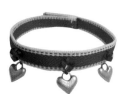

Fold the ribbon in half, and fold in 1cm at both ends.

(Folding the fabric in two reinforces the choker)

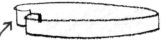

Secure the folded ribbon with dress pins. Sew along the border of the ribbon to complete the main part of the choker.

❷ Attach the Velcro

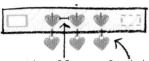

Sew the soft part of the Velcro on the other side.

Sew the coarse part of the Velcro here.

❸ Sew your adornments on

Center of ribbon

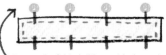

Leave 2.5 cm in between

Sew the bottom hearts lower so that they dangle from the edge.

Finished!

A 65 cm piece of ribbon creates a choker with a diameter of 26 cm. You can change the size depending on how big your cat is. Be sure to measure your cat's neck beforehand so you don't make the choker too tight. Have fun!



Fashion Cats
Feline Couture from Japan's #1 Cat Tailor

FIRST PUBLISHED IN THE UNITED STATES OF AMERICA IN 2011 BY:

VICE BOOKS
97 North 10th Street, Suite 202, Brooklyn, NY 11211
Viceland.com / VBS.TV

Edited by Amy Kellner and Ellis Jones
Layout by Stacy Wakefield
Translated by Lena Oishi

DISTRIBUTED BY:

powerHouse Books
37 Main Street, Brooklyn, NY 11201
PHONE 212 604 9074 FAX 212 366 5247
powerHouseBooks.com

FIRST EDITION 2011 / 10 9 8 7 6 5 4 3 2 1

PRINTED AND BOUND IN SINGAPORE

ISBN: 978-1-57687-557-5

Originally published in Japan in 2009 as *Prin's Fashion Show*

Author: Takako Iwasa
Costume Design: Cat Prin - Tailor of a Cat (Takako Iwasa)
Publisher: Takayuki Kato
Photographer: Tomokaflex
Producer and Editor: Mineko to Kenta Jimusho (Misuzu Uemura)
Book Design: Harmoniz Design (Masataka Matsumori, Yumiko Yanagisawa)
Special Thanks: Vice Japan, Karanomori Co. Ltd. (Keiko Yamashita), Pet Office Inc., Neko no Zakkaya Le Chat

Cat Prin Website: www.cat-prin.com